148

HOWARD HALL'S

guide to

Successful Underwater Photography

First Printing, September 1982
Second Printing, May 1985
Third Printing, March 1987

Illustrations by Michael Farley
Cover Design by James Graca
ISBN 0-932248-03-9
Library of Congress Catalog Card Number 82-61189

Marcor Publishing, 2685 Bolker Way, Port Hueneme, CA 93041

Contents

1. *Introduction: A New Approach* 5

2. *Fundamental Photographic Principles* 11

3. *What Happens to Light Underwater* 23

4. *Available Light Photographs* 37

5. *Silhouette Photographs* 51

6. *Extension Tube Photographs* 61

7. *Reflex Macro Photography* 81

8. *Marine Wildlife Portraits* 99

9. *Photographing People* 113

10. *Close Focus Wide Angle Photos* 129

11. *Nikonos 35mm and 28mm Lenses* 141

12. *Selling Underwater Photographs* 155

13. *Automatic Exposure Photography* 173

Equipment Appendix 183

Index 195

Foreword

When I first started using a camera underwater I said to my husband, "Ron, there must be one way to take photographs that's better than any other, just tell me that one way, I don't want to be confused by anything else." By taking Ron's advice and sticking with it, I have become a competent professional underwater photographer.

Now, Howard Hall has written a book telling everyone a way to take underwater photographs that's better than any other way and in a language that's clear, to the point, and easily understood.

A rare combination of artist and technician, Howard shares with the reader knowledge it has taken him years of experimentation and hard work to accumulate. Extremely generous of information, it is the finest book on underwater photography I have ever managed to understand completely.

Both the beginner and more experienced photographer wise enough to follow Howard's advice will quickly find they are taking better pictures. This is without a doubt the most sensibly written and beautifully illustrated book on the subject of underwater photography Ron and I have ever had the privilege of reading.

Ron and Valerie Taylor

Introduction: A New Approach

A truly new idea

is a very rare thing. The person who invented the wheel had a new idea, and since then civilization has made countless modifications of that idea. The same is true with photography. Most of the beautiful underwater photographs that you see published in magazines are not the products of new ideas, but are the result of modifying old ones. The photographers who take these photographs simply apply well known underwater photographic techniques to the subjects they encounter. The resulting photo is unique, perhaps even a work of art, but the technique is generally as old as the double hose regulator.

I'm not implying that superior underwater photography requires no talent. Certainly, talent is a valuable asset to a photographer. However, it is in "seeing" the potential photograph in a subject that requires some degree of talent, and not the snapping of the shutter. Choosing the lens, positioning the strobes, and balancing the exposures are simply mechanics: aspects of techniques that have already been worked out through a long process of trial and error. So why try to reinvent these techniques?

If you understand the formulas used to take the various kinds of underwater photographs that you see published, then you should be able to apply those same formulas to subjects you are familiar with. Only then can you test your talent. You don't have to come up with a new underwater photographic technique. You only have to recognize your subject's potential, and then apply the proper formula.

NEW APPROACH TO UNDERWATER PHOTOGRAPHY

This book describes the underwater photographic techniques used to take the various types of underwater 35mm photographs that you see published. The 35mm format is the most common one used for wildlife photography and it is the format most publishers expect to receive from professional contributors. However, the techniques described in this text can also be applied to other popular film formats.

My approach is different than those presented in other underwater photography texts. Instead of discussing in detail everything there is to know about underwater photographic equipment, leaving it up to the reader to develop his own techniques, I have used the reverse approach. This text discusses the photographs themselves, emphasizing the techniques used to take professional quality photographs. It also includes numerous example photographs specifically illustrating the techniques and equipment used to take them.

Each chapter in this book will tell you how to take a specific type of underwater photograph. The photographs have been categorized according to the techniques and equipment used to take them. The names I have used to categorize these photographs are entirely arbitrary (I made them up). In some cases these names don't exactly define all of the techniques used to make the photographs they describe. However, these arbitrary names do serve to separate one set of techniques from the next.

There may also be considerable overlap between one chapter and another, since a Wildlife Portrait can certainly be a Macro photograph, and a Silhouette is certainly an Available Light photograph. But there are certain techniques that separate each chapter from the next, and these will become apparent as you read through the text.

PHOTOGRAPH EVALUATION

Each photograph in this book is accompanied by a detailed evaluation of the techniques used. Once you have studied these

chapters, you should be able to recognize the same techniques when paging through a diving magazine. In fact, you should be able to look at nearly any published underwater photograph and categorize it under one of my arbitrary names. Then you should be able to evaluate, in detail, the equipment necessary to take the photo and the techniques employed. You will then have developed the skill of photograph evaluation, which is an extremely important skill for any photographer.

Once you have become skilled at photograph evaluation, the pages of diving magazines will hold few mysteries for you. You will know how to duplicate the results you see, and given similar subject material, you will be able to create photographs of equal quality. Soon every underwater photograph you see will become a stimulus for new ideas. You will see a photo you like, evaluate it, and begin thinking of familiar subjects in your diving area to which the formula can be applied.

THE LIMITATIONS OF EQUIPMENT

Fundamental to evaluating an underwater photograph is being able to recognize the kind of equipment that was used to take it. In order to take a similar photograph, one must use similar equipment. The photographs in Chapter 10 (Close Focus Wide Angle Photographs) are particularly good examples of this.

These photographs were taken with a super wide angle lens, focused at nearly one foot, with an extreme upward camera angle, using a wide angle strobe, and an aperture setting of f-8 to f-16. This is a popular technique and produces beautiful photographs. The key ingredient is the super wide angle lens.

If you attempt to duplicate this technique with a Nikonos 35mm lens, however, you will be disappointed. The 35mm lens is good for several kinds of underwater photographs (see Chapters 6 and 11), but it can not be used to take Close Focus Wide Angle Photographs. If you do try to use the 35mm lens, you will probably get an image, but it will usually be unsharp, with poor perspective and poor colors. It will certainly be disappointing when compared to the CFWA photographs that you see published.

You should approach underwater photography in one of two ways. One, evaluate a photograph you like, then buy or borrow the equipment which that formula requires, and apply those techniques to suitable subjects. Or two, choose ideas with equipment requirements that lie within the limitations of the gear you have.

If you have a Nikonos, a 35mm lens and a small strobe, work on photographs that this system is capable of producing well. You will be much better off learning to take one type of photograph exceptionally well, rather than trying several ideas without the proper equipment, and obtaining consistently poor results.

The chapters in this book evaluate different types of underwater photographs that require different camera systems. By reading these chapters you should be able to decide which photographic techniques fall within the limitations of your equipment. Or, if you really like an effect that you are not presently equipped to work on, you should be able to determine what you will need to add to your system.

The appendix has photographs and descriptions of equipment that are referred to in this book. It is a helpful reference designed to give you a better knowledge of the types of equipment mentioned in this book. It can also give you a good idea of the variety of equipment available on the market, so that you can better evaluate and determine the needs of your own system as your knowledge and expertise in underwater photography increases.

HOW TO USE THIS BOOK

The chapters in this book should be read in sequence the first time around. If you already have an understanding of basic photographic principles, you can skip Chapter 2. If, however you are not sure what an "f stop" is, then Chapter 2 is a must. If you are just starting out there is enough information in Chapter 2 to enable you to understand and employ all of the techniques found in the following chapters.

Although an in-depth knowledge of photographic principles is an advantage to an underwater photographer, it is not entirely necessary for taking professional quality photographs. I know several excellent underwater photographers who get along very nicely with less knowledge of basic fundamentals than is covered in Chapter 2.

After you read this book through once, you will have an understanding of how to evaluate most underwater photographs. Try paging through a diving magazine to evaluate some of the photographs you see. Choose a photograph you like, then go back and study the chapter dealing with that type of photograph. Make sure that particular kind of photograph falls within the limitations of your own underwater photographic equipment.

Next, begin thinking about what subject material there might be in your area that would lend itself to producing that kind of photograph. Then try your skills underwater. Use your entire roll of film to concentrate on that specific type of photo (instead of snapping photos of every interesting thing that swims by).

After developing your photographs, use your evaluation skills to locate any errors you may have made. Continue to work on that type of photograph before you move on to another. In no time at all your results will be of publishable quality.

Fundamental Photographic Principles

Chapter 2

The technical information

available on photography fills volumes of books. The complex nature of optics, camera movements, electronics, and film emulsions often goes beyond the interest of most people. A good underwater photographer does need to know what an f stop is (at least in a basic way), but you can get by quite successfully without knowing very much more.

Some photographers will overwhelm you with what they know (and what you don't know) about emulsion reticulation, hyperfocal distance, and barrel distortion, but their knowledge doesn't necessarily make their photographs any better than yours. The real talent in underwater photography is in "seeing" the potential photograph in a subject and not in what you can memorize from a technical manual.

This is not to imply that your photographic abilities won't be enhanced by the study of technical photographic literature. It simply means that what you need in order to take excellent, professional quality underwater photographs is a basic knowledge of three things: 1) You need a working understanding of a few important photographic principles governing exposure, depth of field (focus) and lens angles, 2) You also need to understand what happens to light underwater (this will be discussed in the next chapter), and 3) you need to learn how to evaluate the underwater photographs you see published in order to apply similar techniques to your photography.

EXPOSURE

Getting the proper exposure on the film is determined by three things: film speed (ASA rating), lens aperture (f stop or f

number), and shutter speed. You make proper exposures by manipulating these three factors in a very uncomplicated way (especially underwater).

FILM SPEED

The film speed is a determination of the film's sensitivity to light, and is given with each kind of film as an ASA rating. ASA stands for American Standards Association (in case you want to impress somebody). The ASA numbers are arbitrary and serve to compare one film to another, providing an index for setting your light meter. The higher the ASA number, the more sensitive the film is to light. A film with twice the ASA number is twice as sensitive. Therefore, an ASA 100 film is twice as sensitive (twice as fast) as ASA 50 film, and so on.

There are many different films from which you can choose for general photographic purposes. However, most professional underwater photographers use a relatively limited number of color slide films. Ninety-nine percent of my underwater photography is done with one type of film: Kodachrome 64.

Kodachrome 64 film is used to produce color slides (transparencies), and is a good all around speed (ASA 64) for underwater photography. Most publishers prefer seeing and printing slides, which is an important consideration for pros and aspiring pros. Also, slides are much less expensive to develop than using negative film and making prints (especially since about seventy-five percent of the photos you or I shoot end up in the round file). If you want to make a print from one of your slides, it can be done by a professional lab or by Kodak without any problem.

Ektachrome 64 is also a good film, but it has heavier grain (tiny grains of light sensitive silver) than Kodachrome, and it has a tendency to produce a blue cast to most underwater photographs. As you will see in the next chapter, we have more blue than we need underwater, and I therefore prefer not to emphasize it by using Ektachrome. However, many professional underwater photographers like the enhanced blues that Ektachrome produces

and they like being able to develop the film at home or in the field, which is something you can't do with Kodachrome.

If you need a faster film than Kodachrome 64, you can use high speed Ektachrome which is available in speeds of either ASA 200 or 400. You might as well use 400 since there is very little difference in quality between the two. I very seldom use these high speed films since some quality must be sacrificed (especially in the form of increased grain size) when you change to higher speeds.

If light levels are very low, it is sometimes necessary to use high speed film, so occasionally I do. I use high speed Ektachrome about once in every 100 rolls of film. If you are just starting out, you should begin with Kodachrome 64 and stick with it until you can find a good reason to change.

SHUTTER SPEED

The second factor in determining exposure is shutter speed. This is how long the shutter stays open, allowing light to reach the film. The numbers you will see on your camera will probably include 30, 60, 125, 250 and so on. These numbers mean that the film is being exposed for 1/30th of a second, 1/60th of a second, 1/125th of a second, and so on, depending on which number you choose. When you change from one number to the next you are either halving or doubling the amount of light that hits the film. For example, 1/30th of a second is twice as long as 1/60th, and 1/250th is half the exposure of 1/125th.

In general, the advantages of using fast shutter speeds are that they will stop the action of the subject (should the subject be moving) and will minimized blurred pictures resulting from camera motion. Camera motion is usually a much larger problem for novice underwater photographers, who are often being bounced across the bottom by water motion. If the camera is moving very much when you shoot, especially at slow shutter speeds, the photo may be blurred. So it's a good idea to try to hold the camera still. Subject motion underwater is not as great a problem as camera motion since most marine animals move relatively slowly and the density of the water tends to buffer sudden movements.

The most important factor in determining the shutter speed you select is the fact that strobes will only synchronize with the camera at certain slow shutter speeds determined by the camera design. Most cameras sync at either 1/60th, 1/80th or 1/90th of a second; that speed will be specially indicated on your shutter speed control. The camera will usually sync at all speeds slower than the indicated sync speed, but you will seldom use these slower speeds with a strobe.

Occasionally, when photographing animals like sea lions or dolphins which move very fast, you might want to forego the strobe and use a higher shutter speed to stop the action. But these situations are rare. Like film types, I am stuck in a groove with my shutter speed. Ninety-nine percent of my photos are shot at 1/60th, primarily because this is the fastest speed at which my cameras will sync with my strobes.

The duration of the strobe flash is very short, nearly 1/1,000th of a second in some cases. So, when shooting close shots where the strobe is your primary light source, the short duration of the flash will do an excellent job of freezing motion. In this case, the slowness of your shutter speed is relatively unimportant.

In determining exposure then, you have now selected your film speed (ASA 64) and you have determined your shutter speed (1/60th). That leaves only one thing to worry about in order to get the right exposure underwater: aperture.

APERTURE

The aperture is the size of the hole within the lens assembly that allows light to pass through to the film. It's set by turning a knob which adjusts an iris. The size of the hole, or aperture, is given in f numbers or f stops.

F numbers are determined by the number of times the diameter of the aperture can be divided into the focal length of the lens (focal length is the distance from the center of the lens to the film). You don't have to remember that, but it might help you to understand why f numbers seem to be such odd numbers.

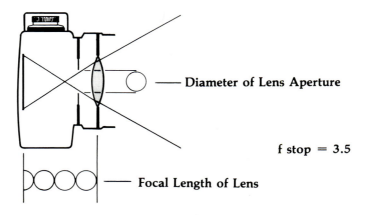

Diameter of Lens Aperture

f stop = 3.5

Focal Length of Lens

F stop numbers are derived by dividing the diameter of the lens aperture into the focal length of the lens.

As with shutter speeds, when you change f stops from one to another you either halve or double the amount of light that reaches the film. F-5.6 passes twice as much light as does f-8, and f-16 passes half as much light as does f-11.

If you change your f number by one stop, the change can be compensated for by changing your shutter speed by one position. Thus, f-8 at 1/60th is the same exposure as f-5.6 at 1/125th.

Aperture is generally determined in one of two ways: either by checking a light meter or by consulting strobe guide numbers (if, of course, you are using a strobe).

LIGHT METER

If you are using a light meter, first adjust the meter to calibrate for your film's ASA rating and for the shutter speed you have selected. Assuming you are following my advice, this means ASA 64 and 1/60th of a second. Once underwater, simply point the light meter toward the subject (or the water behind the subject, as will be discussed in later chapters) and the needle will point to the proper f number.

f-2.8 at 1/500	f-8.0 at 1/60
f-4.0 at 1/250	f-11.0 at 1/30
f-5.6 at 1/125	f-16.0 at 1/15

Each of the above combinations of settings will produce the same exposure, assuming a constant light source. The ability to stop action will vary with the shutter speed. The depth of field will vary with f-stop settings.

GUIDE NUMBERS

If you are using a strobe as your primary light source (as opposed to available light), you will use guide numbers. Guide numbers are determined by the brightness of the strobe and the power setting on the strobe you select. These numbers are usually supplied by the manufacturer. Guide numbers will tell you what f stop to use when a subject is a certain number of feet away.

Above water, light from a strobe drops intensity in a geometric fashion as distance increases. The strobe manufacturer supplies a specific guide number with the strobe, which can then be divided by the strobe-to-subject distance to give you your f stop. For example, if the supplied guide number is 80, and you intend to take a photograph from ten feet away, you should divide the guide number (80) by that distance (10) and this will give you the f stop, (which will be f-8).

Underwater, this doesn't work well because water absorbs and disperses strobe light in a non-geometric fasion. Underwater guide numbers are determined by testing the strobe at various ranges to determine the proper f number for specific distances.

Typical guide numbers for ASA 64 film and an average underwater wide angle strobe are: 1 foot: f-22, 2 feet: f-11, 3 feet: f-8, 4 feet: f-5.6, 5 feet: f-4, 6 feet: f-2.8. Underwater strobes are seldom effective at distances greater than 8 feet (for reasons explained in the next chapter), so there are only eight numbers that you will need to memorize; or, you can write them on the side of your strobe or camera housing for reference.

The guide numbers supplied by the manufacturer with the strobe are seldom accurate and must be refined by tests you make yourself. Guide numbers will vary from one diving environment to the next. Guide numbers determined in tropical coral reef areas will probably need to be increased by a full f stop when diving in the darker waters in northern climates.

DEPTH OF FIELD

You will seldom be exactly accurate in estimating distances underwater, but much of the time the lens depth of field will negate your error. Depth of field is the area in front of the lens that is in acceptable focus. This will vary with the lens aperture you select.

At f-8 on a Nikonos 35mm lens set at a focus of 5 feet, your depth of field is from 4 to 7 feet. This means that everything from 4 to 7 feet away from the lens will be in focus. The smaller the aperture you use, the greater is your depth of field. Thus, at f-16 on the Nikonos 35mm set at a focus of 5 feet, your depth of field is from 3¼ feet to 12 feet. Depth of field is indicated on Nikonos lenses by two red indicators that change with aperture adjustment.

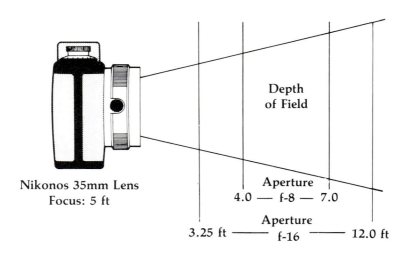

Depth
of Field

Nikonos 35mm Lens
Focus: 5 ft

Aperture
4.0 — f-8 — 7.0

3.25 ft ——— Aperture f-16 ——— 12.0 ft

Depth of field will vary with the lens aperture setting that you choose.

The above photograph illustrates the difference in depth of field between the Nikonos 28mm and 35mm lenses, when using the same focus and aperture settings.

Depth of field also varies with the lens you choose. The wider the lens angle, the greater will be the depth of field. for example: the Nikonos 35mm lens set at f-8 and focused at 5 feet has a depth of field of 4 to 7 feet. The Nikonos 28mm lens (about 30% wider), set at the same focus and aperture, has a depth of field of from 3½ feet to 9 feet.

For most photography with Nikonos lenses, it is best to set the lens at focus settings that maximize the depth of field. For example: if you are shooting subjects at near infinity, set the lens so that the infinity symbol is just inside the depth of field indicator. This will maximize the area before the lens that will be in focus. This is especially helpful when photographing moving subjects.

LENS ANGLE

There is a wide variety of lenses used for underwater photography. By studying the following chapters in this book, and by learning how to evaluate photographs, you can determine what lens you will need in order to duplicate an effect you see either in this book or in a magazine.

Generally, underwater photographs can be broken down into one of two categories in regards to lenses. Either they are macro photographs or they are wide angle photographs.

When taking wide angle photographs, the choice of lens will have a great influence on the effects you can produce. You will gain an understanding of the effect lens angle has on photographs as you study the remainder of this book. However, it may be helpful to compare the various wide angle lenses available.

Generally (excluding some exceptions in ultra wide angle lenses such as the Nikon 16mm) the shorter the focal length of the lens, the greater the lens angle. For example: the 28mm Nikonos lens is wider than the 35mm. Lens angles are measured from corner to corner on the transparency. The following illustrations show the comparison between common underwater lenses and give the lens angles. All of the photos were taken from 4 feet.

55mm Reflex Macro Lens

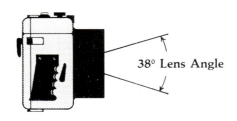

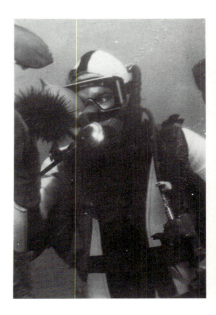

Nikonos 35mm Lens

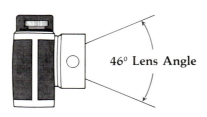

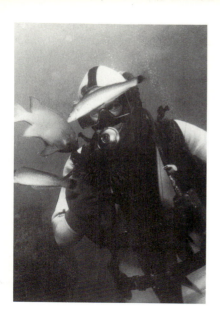

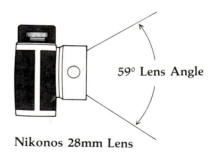

59° Lens Angle

Nikonos 28mm Lens

Nikonos
15mm Lens

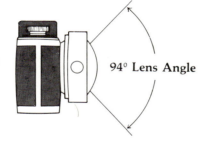

94° Lens Angle

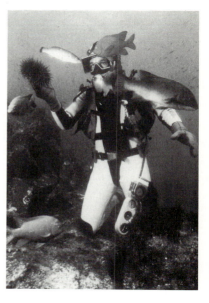

Nikon 16mm Full Frame Fish Eye Lens

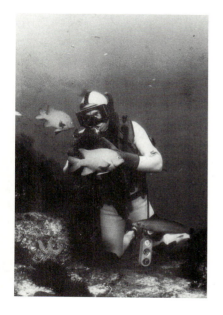

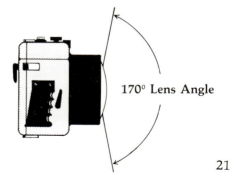

170° Lens Angle

21

FOCUSING

There are two ways that you can focus on a subject, depending on the type of camera system you are using. If you have a single lens reflex camera with through-the-lens viewing, then you will just look through the lens, adjust the focus control until the image in the viewfinder is sharp, and take the picture. If you have a Nikonos, you must decide how far away the subject is from you, set that estimated distance on the lens, and then take the picture.

Sometimes this latter method becomes a little confusing because water refraction through the mask makes things look closer than they actually are. So what do you do? Do you set the focus at the distance the subject appears to be or the distance you think it is after taking into consideration refraction? This problem is further compounded by the fact that many experienced divers automatically compensate in their minds for the distance variation, and generally see things at their actual distance.

The best answer to the problem is simply not to worry about it. Set the focus for the apparent distance and don't try to analyze it. Generally this setting will be close enough, and if your first roll of film reveals a general tendency to focus too far away or too close, then compensate on your next try.

What Happens to Light Underwater

Before attempting to employ

the techniques for taking underwater photographs given in the following chapters, it is important to become familiar with the properties of underwater light and the limitations that these properties place on underwater photography. Although there are countless similarities between topside and underwater photography, there are also some major differences. In some ways, underwater photographic techniques are opposite that of topside techniques. The choice of lens angle is a good example of this.

In above water wildlife photography (as well as many other kinds of above water photography) the telephoto lens is a primary tool. The idea is to use a telephoto lens to photograph an animal that is far away so that the animal in the photograph appears close up. Much of the time this is the only way you can get close to certain species of wildlife.

Underwater, however, you do just the opposite. You start by getting close to the animal and then use a wide angle lens to make it look farther away. There are several properties of light underwater that make this reverse approach necessary. It would be nice to be able to take telephoto pictures over long distances underwater, but for several reasons (some obvious) it doesn't work.

COLOR ABSORPTION

Color absorption is a major problem for underwater photographers. As light penetrates water, some of it is absorbed. But it is not absorbed evenly across the color spectrum. The long wave lengths of light (toward the red end of the spectrum) are absorbed faster than the short wave lengths (blue end). By the time

you have descended thirty feet, you will have difficulty seeing any red color. But this loss of red light doesn't suddenly take place at thirty feet; it begins within inches of the surface. Even a few feet down, colors are severely distorted toward the blue end.

Your brain has the ability to compensate for a large amount of this color distortion, so that at depths even greater than thirty feet you can still see bright colors. But film does not have this compensating ability. The film you will be using is balanced for daylight, which means that it will produce natural colors when exposed by light of very specific color proportions—sunlight. If you alter these color proportions very much, the colors in the photograph will appear very strange.

You may have noticed this effect if you have seen pictures taken indoors under tungsten lights with film balanced for daylight. The colors appear very orange and entirely unsatisfactory, even though the light seemed fine when the photo was taken.

The same kind of color imbalance occurs immediately below the surface in underwater photographs. At a depth of just ten feet, colors that seem bright when you see them will appear blue and washed out in your photographs. Your eye compensates for the color loss, but the film is incapable of doing so.

In order to combat this problem you must do one of three things: #1) Take the photo in extremely shallow water, perhaps using a color correction filter. #2) Use artificial light (strobe). #3) Take the kind of photo in which color contrast is not important.

FILTERS

If you attempt approach #1 (shooting in very shallow water with available light) some of the remaining color distortion can be reduced with a color correction filter like the CC30R. This filter is magenta in color and redistorts the light coming through it toward the red end of the color spectrum.

Filters do not add colors to the light that passes through them, they only selectively remove some of the colors. In the case

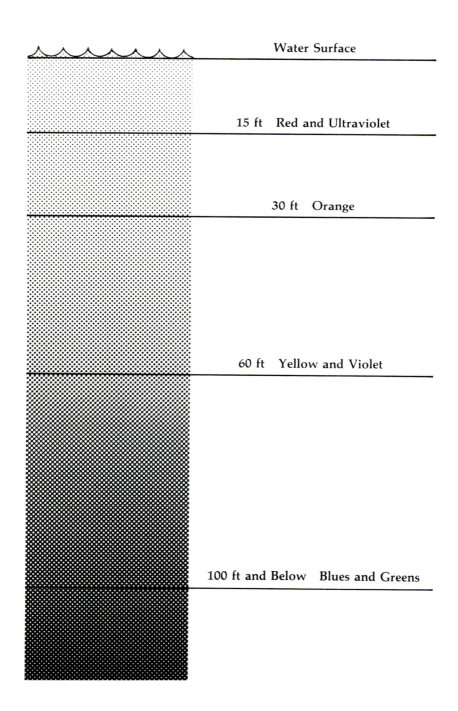

Water Surface

15 ft Red and Ultraviolet

30 ft Orange

60 ft Yellow and Violet

100 ft and Below Blues and Greens

VERTICAL COLOR ABSORPTION

of the CC30R, it removes some of the blue light but allows red light to pass through unhindered. At a depth of ten feet the CC30R will significantly improve the color balance of your photographs. These improvements will be most noticeable in improved skin tones on divers. The deeper you go, the less useful the filter becomes. At depths below twenty feet, there is so little warm color that the filter may be of no value at all.

Since filters selectively hold back some light, they serve to reduce the overall quantity of light that reaches the film, thereby influencing your exposure. Filters will come from the manufacturer with a "filter factor" number which will tell you how much you must increase your exposure to compensate for the filter. You can also place the filter in front of your light meter and simply observe the drop in exposure reading.

HORIZONTAL COLOR LOSS

Color is not only absorbed as it passes vertically through water, but as it passes horizontally as well. Although this seems obvious, it seldom occurs to novice photographers. If you do decide to shoot photographs in ten feet of water or less, you still must get as close to your subject as possible in order to obtain good colors.

If the subject is ten feet away from you, even in six feet of water, you will have very few warm colors in your photos since light must travel six feet down and then ten feet from the subject to the lens. This is a total of sixteen feet and nearly all of the warm colors will be filtered out.

Horizontal color loss is also the reason that underwater strobes are not very effective beyond eight feet, no matter how powerful they are. When using a strobe to photograph a subject that is eight feet away, the light must travel eight feet from the strobe to the subject and an additional eight feet from the subject to the lens. Again, this is a total travel distance of sixteen feet and much of the warm colors will be lost.

In order to obtain good colors underwater, you must get close to your subjects, whether shooting available light

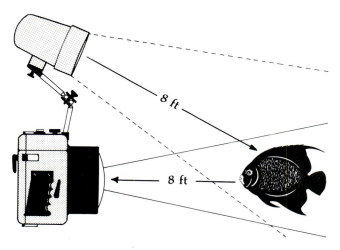

As illustrated above, light must travel from the strobe to the subject and then to the lens. The greater the distance, the greater the horizontal color loss.

photographs in three feet of water or using a strobe in deeper water. When shooting macro photographs this is seldom a problem, but when photographing divers, seascapes, or large animals, it means you must use as wide a lens as possible.

STROBES

Whenever you see an underwater photograph that has any warm colors or any color contrast at all, you can assume that an underwater strobe was used (unless it was taken in a few feet of water). Often the artificial lighting in the photos you see published will be very subtle. All the warm colors are there but it is not obvious that a strobe was used to illuminate the subject. This is exactly the effect that the photographer wanted to create.

In wide angle photographs a strobe is often used only to "paint" in the colors that wouldn't otherwise be there. Recognizing whether or not artificial light was used is an important step in evaluating underwater photographs.

There are three sources of artificial light that photographers use: movie lights, flash bulbs and strobes. The only practical selection for the underwater still photographer is strobes.

COLOR AND EXPOSURE

Strobes are used to do one of two things for an underwater photograph. One: strobes add colors to the photo, which otherwise would have been monochromatic (of one color—blue in this case). Two: they add exposure as well as colors.

In the first case, a strobe is used to bring out colors in a photograph that otherwise would have been exposed solely by blue or green available light. The strobe is not used to influence the exposure of the photograph, it just "paints" in the colors. This is called "fill lighting" or "balancing" and is a technique used extensively in wide angle photos. The technique of balancing will be discussed at length in Chapter 7.

In situations where there is not enough light to produce satisfactory depth of field (as in close-up or macro work), the strobe is used as the primary light source. This is called primary source lighting, and will be discussed at length in Chapter 6.

In either case, strobe light (or any artificial light) has the same limitations as does natural light in regards to color absorption. Strobe light is filtered as it passes through water. By the time it reaches the lens, it may be greatly distorted toward the blue end of the spectrum. This is one reason why it is best to get as close to your subjects as possible; so that the strobe light passes through as little water as possible. Generally, this means closer than eight feet, and it is one of the primary reasons that wide angle lenses are so important underwater.

No matter how powerful your strobe is, if you are beyond eight feet from your subject your photograph will tend to be monochromatic. The strobe may serve to fill in some shadows at ranges beyond eight feet. It may also add some definition to subjects by making them a slightly different shade of blue than the background, but it will do little to bring out warm colors.

When using a strobe to photograph subjects at ranges near eight feet, a color correction filter (CC30R) may help improve the strobe fill colors. This is a very reasonable technique; however, I seldom use it, preferring to concentrate on getting closer to my subjects.

Eight feet is not some magic number in regards to strobe-to-subject distance. Colors brought out by the strobe at seven feet are not always going to be satisfactory and colors accentuated at nine feet will not always be unsatisfactory. The colors illuminated by your strobe will simply improve the closer you are. If the colors you capture at five feet are good, then the colors at four feet should be better. I seldom bother photographing subjects from further than eight feet if I think color will be important to the photograph.

BACKSCATTER

Backscatter is an underwater photography problem produced directly by the strobe. It appears as white snow on the photograph. Some of the white spots will be tiny pin points of light while others will be larger, out-of-focus white blobs. Backscatter is caused by the strobe illuminating suspended particles which reflect light back to the lens.

Water conditions play a great role in determining the degree of backscatter in your photos. The poorer the water visibility, the more debris in suspension, and the greater the chance of backscatter in the photo. However, even greater contributing factors are strobe lighting and diving techniques.

DIVING TECHNIQUES

Most backscatter is caused by debris that the photographer or his buddy has kicked up. This problem can be minimized by taking a few precautions.

Always try to use as little movement as possible when approaching a subject. If given a choice, approach the subject from a down hill side so that you will be below it when you position youself for taking the photograph. Suspended material will tend to drift down a slope rather than up it, and if you approach your subject from above you will often cover it with a cloud of mud.

Try to maintain neutral buoyancy when swimming over the bottom where you hope to find subject material. Then, once you

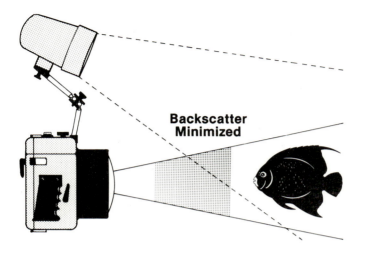

Backscatter Minimized

The above illustration indicates correct strobe placement when photographing with a single strobe. The strobe should be held over the subject and away from the lens, but never at an extreme angle.

have positioned yourself, let some air out of your compensator so that you can remain immobile. If you are diving with a buddy, you might threaten him with bodily harm if he kicks up the bottom around your subjects.

STROBE PLACEMENT

Once you have positioned yourself, much of the remaining backscatter problems can be minimized by proper placement of the strobes. The closer the strobe is to the lens, the more particles will be illuminated.

The particles closest to the lens will produce the large, out of focus spots that can ruin a photograph. Particles near the subject will appear as small pin points of light which may not affect the photo's quality very much. By holding the strobe over the subject and away from the lens, you can avoid lighting up the most detrimental particles.

Excessive backscatter is caused by placing the strobe too close to the lens. It can easily ruin a photograph.

Correct placement of the strobe will help keep back-scatter to a minimum.

Unfortunately, when you place a single strobe at too extreme an angle to your lens, you tend to produce extremely harsh shadows on the subject. This problem is most noticeable in photographs where the strobe is being used as the primary light source (available light contributing little to exposure).

Dramatic improvements in your macro photography can be made by the use of two strobes (as detailed in Chapter 6). Two strobes will not only greatly reduce harsh shadows, but will allow you to place the strobes in positions that nearly eliminate scatter.

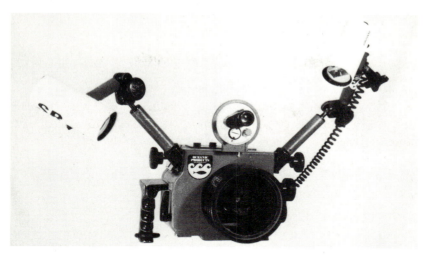

The above photograph illustrates proper positioning of 2 strobes, which will reduce harsh shadows and help minimize backscatter.

SCATTER

If you look at distant mountains on a hazy day, especially through binoculars or a telescope, you will notice that the image is not well defined. The reason is that suspended moisture and dust in the air, as well as variations in air density, alter the path of light as it approaches you. By the time light reaches you from the mountains, it has been bounced around a bit and the images have lost sharpness and detail.

The same thing happens underwater, only to a much greater extent. You may think that 200 foot visibility is clear water, but compared to water under polar ice where visibility reaches in excess of 800 feet, the best tropical water would be considered murky. Even in 200 foot visibility there is a lot of suspended material floating around that can scatter images. Subjects only a few feet away can begin to lose sharpness and detail in your photographs.

The impact that this problem has on underwater photography is enormous. It is one of the primary reasons that wide angle lenses are so important for the underwater photographer. It is also the reason that telephoto lenses are nearly

useless underwater. An image photographed with a telephoto lens from fifty feet away in 200 foot visibility, will have almost no sharp detail.

The same is true with a wide angle lens, except that you would almost never use one at that range. Subjects photographed from only twenty feet away in clear water are seldom very sharp. In order to get sharp images, even in clear water, you must get close to your subjects. The closer the better.

For underwater photography other than macro, wide angle lenses are the primary tools. They allow the photographer to get as close to the subject as possible, thereby minimizing loss of sharpness due to scatter as well as loss of color as it travels from strobe to subject to lens.

REFRACTION

Refraction creates a few minor problems for underwater photographers. The confusion it creates in estimating distance makes focusing with a Nikonos a little frustrating at first. But with a little practice it is not difficult to get the hang of it. Refraction also creates some minor optical problems for cameras used in underwater housings. In addition, refraction sometimes makes the faces of people look distorted behind their face masks.

The distortion of faces behind diving masks is caused by the bending of light as it passes from the air in the mask, through the glass, and into the water. The more the subject's face is turned away from the photographer, the greater the distortion. To minimize this problem it is best to have your subject keep his face turned as much toward the camera as possible.

If you have a camera in an underwater housing, it may be of some value to understand the optics of dome versus flat ports (this is the part of the housing that the lens looks through). Since nearly all professional quality housed camera systems are "through the lens" viewing systems, you won't have to worry about estimating distance when focusing. But you will notice some differences concerning focusing and image size between dome ports and flat ports.

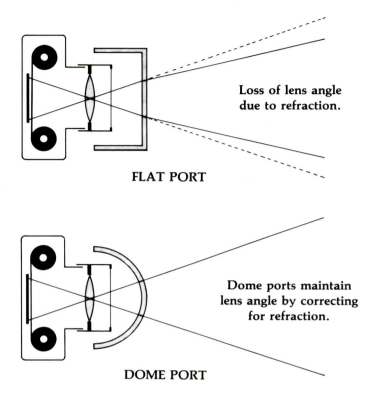

Loss of lens angle due to refraction.

FLAT PORT

Dome ports maintain lens angle by correcting for refraction.

DOME PORT

A flat port will be subject to refraction just like your face mask. It will tend to make things look (to the lens) about 25% larger and closer. This effectively reduces the picture angle of the lens making a 28mm lens take photographs with the picture angle of a 35mm lens.

In addition, refraction through flat ports also tends to distort the edges of wide angle photographs. For these reasons wide angle lenses sould be used behind dome ports. Dome ports allow the wide angle lens to retain its full picture angle as well as prevent edge distortion.

Macro photography, on the other hand, may be done more effectively behind a flat port, since the refraction through the port gives you increased magnification. Macro photography can be done behind a dome port also, but if you can focus down to an

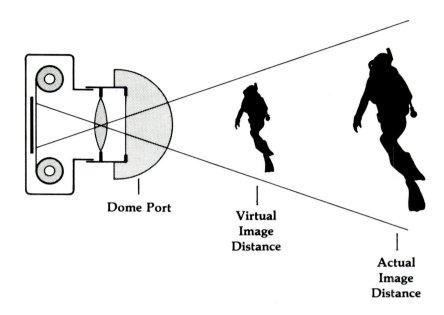

Dome Port

**Virtual
Image
Distance**

**Actual
Image
Distance**

image three inches across with a dome port, then you will be able to focus down to an image two inches across with a flat port. The flat port allows you to photograph smaller subjects.

VIRTUAL IMAGE

The dome port acts as an additional optical element to the lens and has specific optical properties of its own. It is not just a simple window. Although the dome port allows the lens to retain its full picture angle, it creates an image which the lens sees only a few inches outside the dome. This is called the "virtual image." The lens must be capable of focusing on this image.

For a subject focused at infinity, the virtual image is generally located at a distance four times the radius (or twice the diameter) of the dome away from the focal plane (where the film is). If your housing utilizes a five inch dome, then the virtual image will be located ten inches away from the focal plane. If the wide angle lens you are using doesn't focus that close, then you will have to add a diopter, or close up lens, to the front of the lens to bring the focus in.

Available Light Photographs

Chapter 4

Underwater available light

photographs are usually monochromatic (one color). A monochromatic photograph is very much like a black and white photo. Underwater monochromatic photographs, however, are composed of various shades of blue or green instead of shades of gray. This fact, combined with the extensive scatter of underwater light, places important limitations on available light underwater photographs.

CONTRAST

Contrast is an extremely important ingredient in any type of photograph. Without contrast there is nothing in the image to catch your eye and focus your attention. And although a photo without contrast may serve to identify a species of fish or verify that your buddy did catch a lobster, it will not be a picture that you will enjoy hanging on your wall or that a publisher will consider printing. Without contrast a photograph has no impact. It has the "blahs".

There are two types of contrast in color photography. The first type is color contrast. An example of color contrast is a bright red balloon photographed against a bright blue sky. If the balloon were blue, then the photograph would not have as much impact.

The other type of contrast is shade contrast. This kind of contrast is important to black and white photographs. It is also the kind of contrast that is important to available light underwater photographs. An example of a color photograph with shade contrast is birds flying through a sunset. The photograph may have only one color (usually orange), but the birds stand out

because they are silhouetted against the background. This is the kind of contrast you must look for in your underwater available light photographs.

In the example of the balloon against a blue sky, it is obvious that a blue balloon would have much less color contrast and impact than a red balloon. But, since this is a topside photograph, there would still be considerable difference between the blue color of the balloon and the blue color of the sky. The photo would still have some color contrast.

Underwater, however, this would not be the case. It doesn't matter what color the subject is underwater, because the light which is illuminating it will be monochromatic, and the color of the subject in the photograph will appear exactly (or very nearly exactly) the same as the background.

You must also remember that any color contrast you see with your eye will seldom be seen by your film. The first time you try to photograph a brilliantly colored angel fish swimming over a coral reef you will be amazed at the blandness of the results.

Therefore, for available light underwater photographs, you should look for shade contrast. As in the example of the birds flying through the sunset, this means dark subjects against light backgrounds, or bright subjects against dark backgrounds. With very few exceptions (a white sandy bottom being one) the background in your available light photographs should be open water.

SEPARATION

Another term for shade contrast often used by underwater photographers is separation. In available light underwater photography, you must concentrate on separating your subjects from their backgrounds. Generally, this means you must get below the subject and shoot at an upward angle. This will usually produce a silhouette, or a partial silhouette, depending on how extreme your upward angle is. Or, if you position yourself with the sun at your back, it will sometimes produce a relatively light subject with a dark water background. In both cases, the background is open water.

The important thing is to make sure you have completely separated your subject from the other objects in the photograph. If you are photographing a diver swimming over the bottom, you must get lower than the diver and maker sure that open water entirely surrounds him before you take the picture (see Photo # 1). If part of the bottom is behind the diver it will act as a camouflage. The diver will appear to be part of the bottom in the photograph and will become difficult to recognize.

SCATTER AND COLOR

When photographing with only available light, it is important that you get as close as possible to your subjects, for two main reasons. First, is the effect of scatter. The further you are from the subject, the more scattered will be the image. In photographs that rely heavily on shade contrast, scatter can have especially detrimental effects. The sharpness of Photograph #3 is due to the fact that it was shot from a distance of one foot. Since the light from the subject traveled so short a distance to reach the lens, scatter had minimal effect.

The other reason you should get close to your subject is color absorption. Although available light photographs will be monochromatic, the shades of blue color (or green) will become more uniform with increased subject distance. The more the shade of the subject differs from the shade of the background, the more separation there will be. This is most true when the sun is positioned at your back in order to get light subjects against dark water backgrounds.

SUN POSITION

As with topside photography, the position of the sun has important effects on underwater photographs. If you want your subject to appear relatively light against a darker background of deep blue water, then you must position the sun at your back (see Photograph # 3). If you want the subject to appear dark, and you wish to accentuate the sun's rays, then the sun should be positioned in front of the lens (see Photos #1 and #2). The time

of day will greatly accentuate the results you get when shooting into or away from the sun.

CHOICE OF LENS

Generally, most available light photographs are taken with wide angle lenses since the subjects are usually divers or other large subjects. It is not impossible to take available light photographs of macro subjects, but it is difficult to get useful results. There are two reasons for this. One is that unless you photograph your macro subject in a rather extreme silhouette, you will be forced to use wide aperture settings. This means that your depth of field will be poor and it will be difficult to get much of your subject in focus. Also, unless you do photograph the subject in silhouette, there will be little contrast and the photograph will suffer from a bad case of the "blahs".

Even if you do try to silhouette a macro subject, it will seldom be a subject that viewers can easily recognize without being able to see more detail. You are generally better off photographing macro subjects with a strobe.

Wide angle lenses are a much better choice than macro lenses for available light photography. They allow you to pursue large subjects and seascapes that viewers can recognize even in silhouette.

NEGATIVE SPACE

Negative space is a key concept in photography, and is defined as everything in the photograph that is not the subject. Negative space can often make or break a photograph. Most beginning photographers think that the subject is all important. But to the experienced photographer, negative space is often equally important and sometimes even more important.

Turn ahead to Photograph #14 in Chapter 7. It clearly illustrates the importance of negative space in a photograph. Hundreds of photographers have photographed this species of nudibranch, so getting just a "good" photo of the animal itself

would be of little professional value. The only way to make this photograph valuable was to create exceptional composition. To accomplish this, I concentrated on the negative space.

It is not the nudibranch itself that makes this photo exceptional, but rather the shape and color of the rock it is on, the small gorgonian coral in the left foreground, and the patch of green water in the upper left. All of these things are part of the negative space in the photograph, and each was given careful consideration in the composition of the photograph before I took it.

When photographing macro subjects, novice photographers usually spend most of their time looking for subjects only. Experienced photographers, however, will often spend more time looking for negative space, and then search for subjects within it.

No matter what kind of photograph you are taking, the care you take in photographing the negative space is often as important as the care you take in photographing the subject itself. When you do a good job with both, your photograph will have excellent composition.

In available light photographs, the negative space will not have the detail that it does in macro photography. However, it is still very important. Before you take your photos, evaluate every square inch of the frame for good or bad negative space. Don't just see the subject to the exclusion of all else in the frame. In some situations you might even want to search for good negative space first, frame it just the way you want it, and then wait for a diver or fish to swim into the frame. Such was the case in Photograph #1 .

SUMMARY OF PROCEDURES

In order to take successful available light underwater photographs, you will need a camera with a wide angle lens and a light meter. Study the examples in this chapter for a better understanding of the limitations of your lens. If you are using a 28mm or 35mm Nikonos lens you should also read Chapter 11, which deals specifically with these lenses.

Once you are underwater and have decided upon a subject (or perhaps a negative space), check your sun position and decide whether you will shoot into or away from the sun.

Position yourself lower than your subject and take a light meter reading on the water behind the subject.

Check your composition. Make sure that your subject is entirely separated from the other objects in the frame by surrounding open water. Check your subject's size in proportion to the size of the frame itself. Evaluate your negative space and make sure that it complements but does not distract from the subject.

Shoot both horizontal and vertical photographs if possible, bracketing your exposure with each. After your film is developed, evaluate your results carefully, taking note of which techniques produced the most pleasing results.

Photo #1 *I call this type of underwater photograph a seascape. In this case it is a photograph of a diver swimming through a California kelp forest. The initial point of interest in the photograph is the diver. However, it is a little deceptive to call the diver the subject since the photograph could stand alone without it. But without the diver, the composition would lack considerable impact.*

When you take this kind of photograph, it is the negative space that is important. You should spend your dive time searching for just the right background. Frame it with your lens so that every part of the photograph is exactly as you want it, from corner to corner. Then, wait for your subject to swim into the frame. You should place your highest priority on the negative space. The subject (the diver) gives the photograph a point of interest.

This photo also illustrates the importance of getting below the subject. Although this photo appears to have been taken from an essentially level angle, in this case looks can be deceiving.

I positioned myself close to the bottom and tilted the camera slightly upward, to frame the diver against open water, rather than against the bottom. Had even part of the diver been framed against the bottom, it would have been difficult to distinguish the subject.

The lens I used to take this photograph was a 24mm Nikon lens on a single lens reflex camera in a housing. Several other wide angle systems would have worked equally well. The wide angle lens allowed me to photograph a large panorama from a short distance away. This prevented the image from being beyond visibility or unacceptably scattered. Had I tried to use a 35mm or 28mm lens, I would have had to back up too far to get the same frame.

In this case, the diver is thirty feet away and visibility is only sixty feet. You will notice that the image of the diver is not entirely sharp, due to the scatter from thirty feet. But the

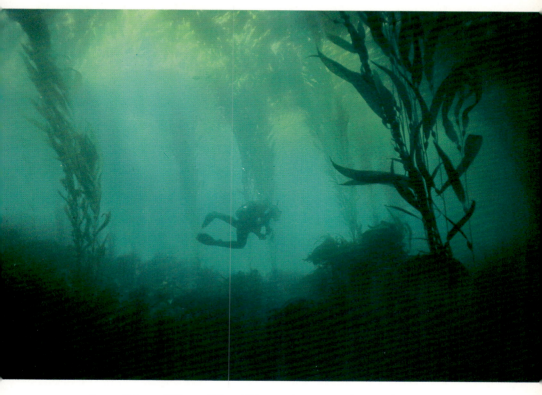

Lens: 24mm Nikon. Film: KR 64. Aperture: f-2.8. Shutter speed: 1/30th. Subject distance: 30 feet. Camera angle: slightly upward. Strobe: none.

small size of the subject and its relative unimportance makes the scatter of the image acceptable.

Since the light in the kelp forest was very dim, I used a shutter speed of 1/30th and the aperture f-2.8, holding the camera as still as possible. Had there been less light, I would have had to resort to high speed film. The exposure reading was taken on the water behind the subject, and the sun was in front of the lens at the upper right.

Photo #2

This photograph was taken by aiming the camera into the sun. When you shoot into the sun, the subject becomes more of a silhouette and you will get increased separation from the background. However, some of the subject's detail will be lost.

The time of day will greatly influence the effects possible for available light photographs. This photograph was taken in the late afternoon with the sun approaching the horizon. At noon, light is relatively even in all horizontal directions. But as the sun gets lower on the horizon, the effects of shooting away from or into the sun will vary dramatically. Shooting away from the sun will produce a darker water background and lighter subjects. Shooting into the sun will produce bright water with sun streaks and dark subjects.

It has been said that the best time to shoot underwater photographs is between 10 am and 2 pm, when the sun is high overhead. This statement is somewhat of an oversimplification. Certainly, some underwater photographs are best taken at high noon, but others are best taken with the sun lower on the horizon. It all depends on the effect you want. As light changes underwater, the effects you can capture on film will vary.

You will notice that about half the photographs in this book were taken in the horizontal camera position, while the other half were taken in the vertical camera position. There are two reasons for shooting both vertical and horizontal photographs. One important reason is that layouts in books and magazines usually need both horizontal and vertical formats. If you hope to publish a double page spread of one of your photographs, you will probably need to submit a horizontal picture. If, however, you want to see your photograph on the cover of the magazine, you will need a vertical shot.

Perhaps an even more important reason for alternating from verticals to horizontals when you are shooting film is that the subject's orientation will lend itself better to one of the two formats. In this photograph, the dolphins were swimming upward and their bodies were oriented vertically.

Lens: Nikonos 15mm. Film: KR 64. Aperture: f-8. Shutter speed: 1/125th. Subject distance: 5 feet. Camera angle: level. Strobe: none.

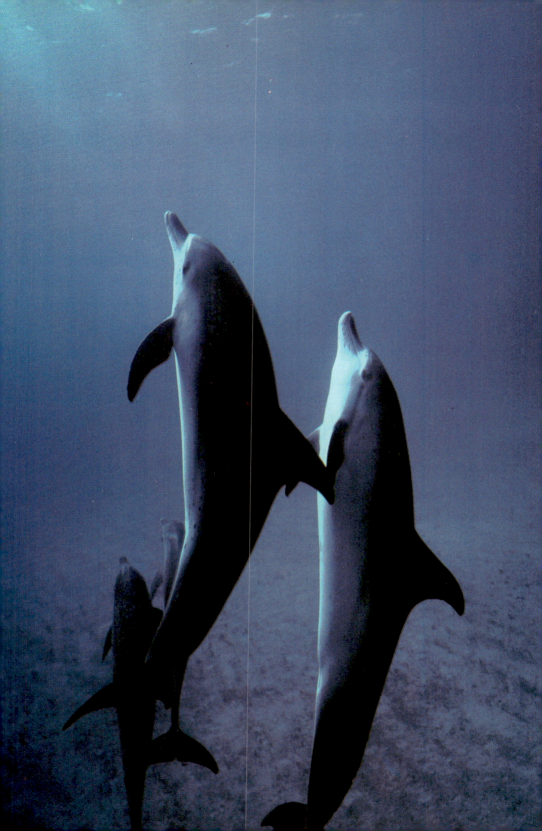

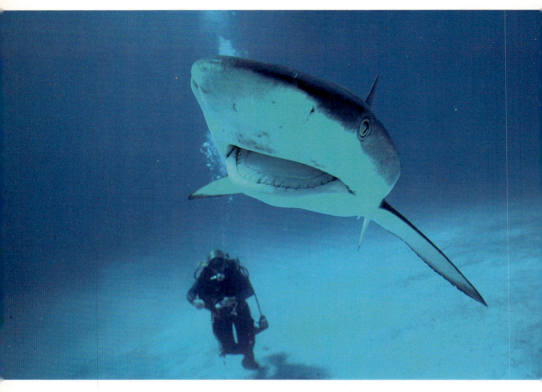

Lens: Nikonos 15mm. Film: KR 64. Aperture f-8. Shutter speed: 1/125th. Subject distance: 1 foot. Camera angle: slightly upward. Strobe: none.

Photo #3 *This photograph of a gray reef shark was taken in the Coral Sea. I used a Nikonos camera and the Nikonos 15mm lens which I pre-focused at one foot before the shark approached. The fact that the sun was at my back did two important things for the photograph. One, it darkened the water above the horizon; and two, it illuminated the white face of the shark. This combination provided acceptable separation between subject and background.*

A slight upward camera angle was used to create separation between the white face of the shark and the dark blue open water above the horizon. Had the shark been photographed against the sand, its white face would have closely matched the white shade of the sand, resulting in a loss of contrast. Had this happened, the photograph would have been useless. As in most available light photographs, the upward angle was of critical importance.

There are two important components of negative space in this photograph. The diver, although out of focus, provides a secondary point of interest and adds depth to the photograph. The diver was darkly dressed and contrasted well with the bright sand.

The sandy horizon is also of value to the photograph, since it tells something about the environment in which the animal lives. Although this photograph would still carry considerable impact had the negative space been only blue water, the two additional components of diver and sandy bottom extend the photograph's value. It is, however, very important that components of the negative space be simple and of secondary prominence in the frame, in order not to distract from the subject.

Now you might suspect that I may not have been thinking of all of these factors while preparing to photograph an approaching shark. Although I may have instinctively considered many factors subconsciously (such instincts come with experience), I was consciously thinking of only two things: 1) shoot when the shark is at the right distance, and 2) get below the subject.

Shooting at the proper distance gave me a sharp image. Getting below the subject gave me good separation. These were the two most important considerations. I much more carefully considered other factors of composition several weeks later when I edited the photographs. The ones that didn't have the proper ingredients were filed in my round file, never to be seen again. The remaining successful photographs are in this book, or have been published elsewhere.

The wideness of the 15mm lens did two important things for this photo. First, it allowed me to shoot the entire face of

the shark from one foot away. This nearly eliminated the scattering of light from the subject to the lens. Had I taken the same photo with a 35mm Nikonos lens, it would have been less sharp; not because of the quality of the lens, but because I would have had to be three feet from the subject, and the light would have been more scattered. Also, the wideness of the 15mm allowed more of the background to be included, which would have been eliminated with a narrower lens.

Silhouette

Photographs

Chapter 5

Underwater silhouettes

are surprisingly easy to take and require a minimal amount of photographic equipment. If you are on a budget you can get by with only a camera and nearly any wide angle lens. Light meters are certainly useful, but if necessary you can get by without one. In addition, good silhouette photographs can be taken in a wide variety of water conditions. It is often the best type of photograph to take when water conditions and subject material make separation difficult.

The idea in taking silhouettes is to take an exposure of the bright water overhead with your subject between you and the surface. The subject will then be underexposed and will appear very dark against the bright background. It is best to position yourself so that you are aiming your lens at the brightest part of the surface. This is where the sun will be.

SUN BURST EFFECT

If it is a sunny day and you are within sight of the surface, the sun will appear as a bright burst of light with dramatic rays penetrating down and out to all sides. Usually, you will want to include this sun burst in the frame. You may also want to place your subject directly between the sun and the lens. This will produce the most dramatic silhouette effect: your subject in the center of a brilliant pool of light with sun streaks shooting out in all directions.

Since these sun streaks move very rapidly, it is best to shoot at 1/125th or faster in order to freeze their motion. The faster the shutter speed, the more dramatic the sun's rays will be.

The center of the pool of light is always extremely bright, so if you take your exposure reading directly on it, you will usually get a maximum reading. Therefore, you should take the reading

to one side of the sun, by about twenty degrees. Under most clear water conditions, where the surface is visible and you are aiming into the sun on a clear day, your exposure will be about f-11 at 1/125th. This is a good guide to bracket around if you don't have a light meter (ASA 64 film, of course).

EXPOSURES

You will find that an unusually wide variety of exposures will work when taking silhouette photographs. If f-11 gives you a good photograph of the sun burst with your subject in silhouette, f-8 will probably be equally acceptable. The difference is that the pool of light around the sun will be larger.

To a large extent, educated guesses of exposure will produce good results. Even if you use a light meter you should bracket your exposures. Most of them should produce good results, but you might like one effect better than another.

If your subject is on or near the bottom, make sure that enough of it is surrounded by bright water so that it will be easily recognizable when seen in outline.

The subject doesn't always have to be in the center of the sun. Sometimes you might want the sun to be at the top of the frame with the subject in the middle. In this case, take the exposure reading on the water directly behind the subject. That particular part of the picture will be the most important to expose properly. The water above the subject may be overexposed and the frame below the subject may be underexposed, but if the water directly behind the subject is exposed properly, then the photograph will usually be acceptable.

If the sun is not visible, or if you prefer to shoot against a more evenly exposed background by aiming away from the sun, then the background will appear an even blue or green color. If the subject occupies a large amount of the frame, as with a school of fish or sharks (see Photo # 6), then you should take your reading at the lowest part of the frame where the subject is still visible. It is better to have the top of the frame overexposed than to have the bottom of the frame underexposed, thereby losing the subject.

SUMMARY OF PROCEDURES

Use a camera with a wide angle lens (35mm or wider) and use a light meter if you have one. Set your shutter speed at 1/125th (unless you need the additional exposure of 1/60th) and focus on your subject's distance.

Position yourself so that the subject is between your lens and a bright part of the surface. Take your light meter reading about 20 degrees to one side of the sun, if you have positioned your subject directly in the sun's path. If your subject is not in the sun burst, take your reading on the water behind the subject. Bracket your exposures.

Photo #4 *This is a silhouette of a diver and a blue shark. I used the Nikonos with a 21mm lens focused at ten feet, and then shot the photo straight up into the sun. I positioned myself below the diver, so that he remained between the sun and the lens. I then swam with the diver, holding that position until the shark approached him.*

I estimated the exposure to be f-16 with a shutter speed of 1/125th. This exposure proved to be about the minimum possible, since the shark is just barely exposed. Exposure increases of one or two stops might also have produced acceptable exposures, since the effect of increasing exposure in this type of photograph is to enlarge the pool of light surrounding the sun.

Estimating exposures for silhouette photographs is not all that tricky. Probably, had I shot anywhere from f-16 to f-8 at 1/125th, the exposure would have been acceptable. This means that it is possible to shoot good silhouettes without a light meter under most conditions, especially if you bracket your exposures. Setting the shutter speed at 1/125th produced the dramatic sun rays in the this photograph by freezing their motion.

Lens: 21mm Nikonos. Film: KR 64. Aperture: f-16. Shutter speed: 1/125th. Subject distance: Ten feet. Camera angle: straight up. Strobe: none.

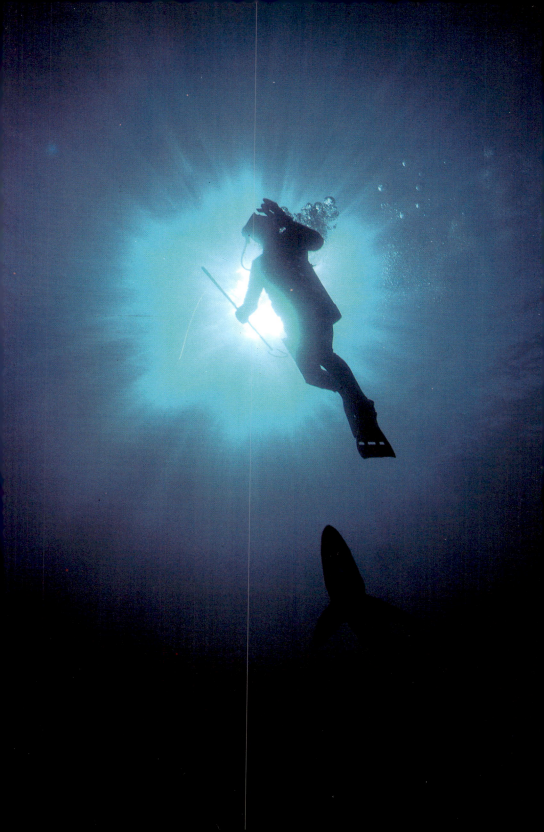

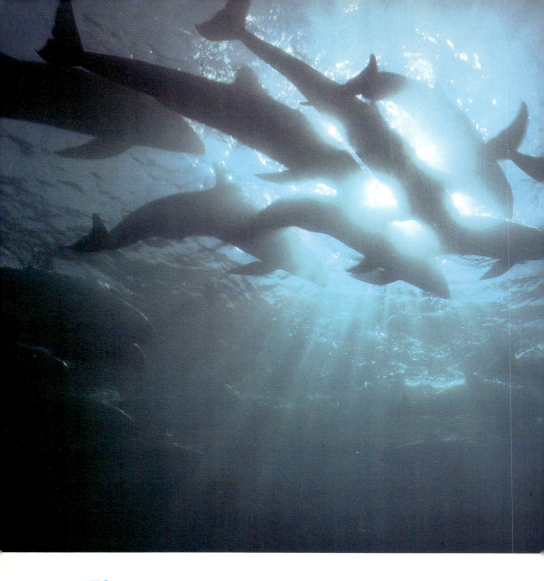

Photo #5 *This is a silhouette of a school of many toothed whales. These animals are similar to pilot whales and are about twelve feet long. I photographed them in a Japanese bay where water visibility at the time was about thirty feet.*

Thirty foot visibility is not very satisfactory for photographing large animals, especially when they are difficult to approach. Photographs taken under such conditions at level angles and from distances of ten feet or more seldom produce sharp images. This is due to scatter and lack of separation (in this case between the gray animals and the gray water).

So, in order to increase shade contrast and apparent

Lens: 15mm
Nikonos. Film: KR 64.
Aperture: f-11. Shutter
speed: 60th. Subject
distance: About 20 feet.
Camera angle: straight
up. Strobe: none.

sharpness, I chose to shoot a large percentage of silhouettes. I also tried several other photographic techniques on the school of whales, but the silhouettes proved most dramatic because they were the only photographs that had any separation.

I used my Nikonos with a 15mm lens and focused on the surface from a depth of twenty feet. I took a light meter reading aimed toward the surface, but to one side of the sun (since readings directly on the sun will nearly always be f-22). I set the aperture at f-11, which gave me an extremely great depth of field. The shutter speed was set at 1/60th, but it would have been much better to have used 1/125th to accentuate the sun's rays and increase sharpness.

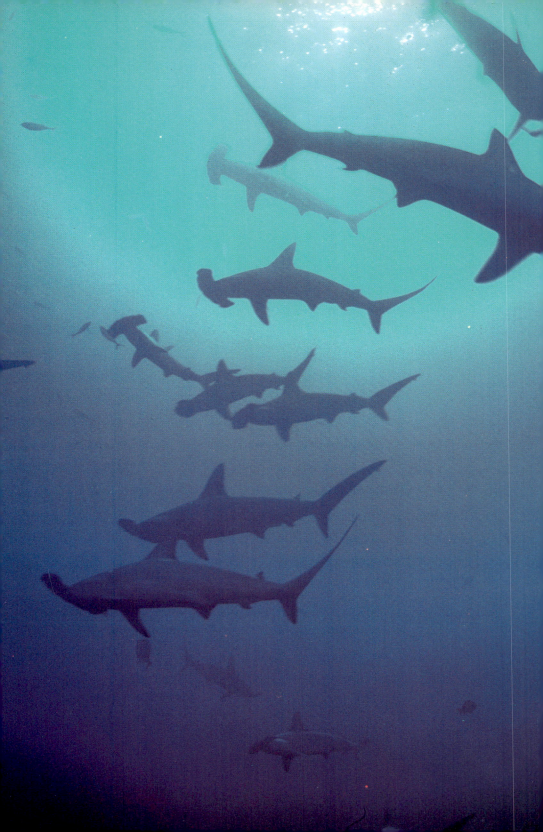

Photo #6 *This school of hammerhead sharks was photographed in the Sea of Cortez in Mexico. In this case (as in Photo #5), I wanted a dramatic shot of a large group of animals and not just a single individual. Although water visibility was nearly 100 feet at the time, I still faced most of the same problems I had with photographing the school of whales in Photo #5.*

In order to get a large group of sharks in a single frame, I had to shoot from at least ten feet away, rendering a strobe all but useless. And since the hammerheads were at a depth of fifty feet, level shots would have produced photographs with scattered images and no shade contrast. Thus, I chose to enhance shade contrast by shooting the sharks in silhouette.

The lens I chose was the Nikonos 28mm lens. In this situation, using the 15mm lens would have been a mistake. The school of sharks was spread out with about six to ten feet between the animals. With the 15mm lens I could have framed one shark properly in th foreground, but sharks more than ten feet away would have been uselessly tiny in the frame.

With extreme wide angle lenses such as the 15mm, the subject to camera distance is critical. If you are too close, the subject overfills the frame; if you are too far away, the subject becomes a tiny speck. Therefore, in the case of the hammerhead school, it was better to shoot from a greater distance with the 28mm lens and get more of the sharks in the frame to be of acceptable size. A 35mm Nikonos lens may also have been an effective choice for this type of photograph.

This shot, unlike Photo #5, was not taken by aiming straight up into the sun, but rather by aiming at a 45 degree angle upward. This angle produces an exposure problem with a wide angle lens. The top of the frame will include the sun (at an exposure of about f-16); while the bottom of the frame, which is only a few degrees above horizontal, will have an exposure of about f-5.6. How, then, do you set the exposure when the subject extends from the top of the frame to the bottom?

Take your reading on the lower part of the frame. If the top of the photo is several stops over exposed it will still

produce acceptable silhouettes. But if the bottom of the frame is several stops underexposed, the subject will not be visible there. In this case, I took my reading from where I thought the bottom of the frame would be, and then used f-5.6.

This problem could have been greatly minimized by shooting a horizontal rather than a vertical photograph, but the subject was oriented vertically and was much better framed that way.

Since f-4 would have given me a poor depth of field with the 28mm lens, I chose to set the shutter speed at 1/60th instead of 1/125th. However, the faster shutter speed would have produced a sharper image.

Lens: Nikonos 28mm. Film: KR 64. Aperture: f-5.6. Shutter speed: 1/60th. Subject distance: about 15 feet on the sharks in the center of the frame. Camera angle: 45 degrees upward. Strobe: none.

Extension Tube Photographs

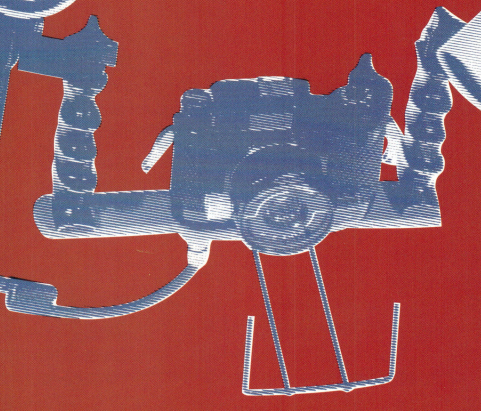

Chapter 6

The photographs discussed

in this chapter were taken with a Nikonos camera, one or two strobes, and extension tubes. Extension tube photography is a type of underwater macro photography. It is simple, easy to do, relatively inexpensive, and can produce professional quality results. For these reasons, this type of underwater photograph is ideal for the beginning underwater photographer.

SPECIALIZATION

When starting out in underwater photography, it's best to specialize in one kind of photograph and become adept at those techniques before moving on to another type. Too often, novice photographers insist on trying to take all kinds of underwater photographs before they ever master one kind. This often results in consistently mediocre photography.

You will become a much better photographer if you choose one of the techniques in this book and master it thoroughly before moving on. Extension tube photography is an excellent place to start. The equipment is simple, the techniques are simple, and the resulting ratio of good to miserable photographs is very high.

I started out with extension tubes. Without any idea of what an "f stop" was, I managed to shoot three photographs among my first half dozen rolls of film which were later published (one of which is in this book).

WHAT IS AN EXTENSION TUBE?

An extension tube is an aluminum tube that mounts between the Nikonos camera and the 35mm lens (extension tubes are also available for the 28mm lens, but are somewhat more difficult to

use). They come in various sizes described as 1:1, 2:1, 3:1, and so forth. These numbers represent the ratio of subject size to image size on the 35mm transparency. In a 1:1 extension tube photo the image is life size on the transparency. In a 2:1 shot, the subject is one half life size. The manufacturer's described size of an extension tube, however, is not always the actual subject to image ratio. This means that one manufacturer's 3:1 extension tube may be a slightly different size than another manufacturer's similar product.

The extension tube comes with a framer that tells you exactly how far the subject should be from the lens and how large the subject should be for proper framing. This makes it easy to choose which size extension tube you want to use. You can simply look at the framer and decide if it will fit the subjects you want to photograph.

The framer is necessary because extension tubes create extremely limited depth of field. Without the framer you would be unable to locate the focus distance and would have difficulty framing your subject properly.

EXPOSURE

In extension tube photography the strobe is used as the primary light source. This means that the light which creates the exposure on the film comes primarily from the strobe (as opposed to coming primarily from ambient light with, possibly, some strobe fill). Since you need to maximize the depth of field, the strobe is held very close to the subject to enable you to use a minimum aperture (usually f-22). In most cases, ambient light has no influence on your exposure.

Camera settings for extension tube photography are simple. You preset them before you dive. Aperture is f-22 (to maximize depth of field), the shutter speed is 1/60th (to synchronize with the strobe, assuming your camera synchronizes at 1/60th), and the focus setting is specified by the extension tube manufacturer (usually 2.75 feet).

Your exposure will be determined by how close to the subject the strobe is placed. The longer the extension tube (not the framer, the tube itself), the closer you must hold the strobe to the subject. Since the focal length of the lens is increased by placing an extension tube between the lens and the camera, the aperture calibrations on the lens are no longer accurate (see "Aperture" Chapter 2). The longer the tube, the less light actually reaches the film. So with a 1:1 extension tube you must hold the strobe closer to the subject than you do with a 3:1.

EXTENSION TUBE EXPOSURE GUIDE

Tube Size	First Bracket	Second Bracket	Third Bracket
3:1	6"	9"	12"
2:1	4"	6"	10"
1:1	2"	4"	8"

The above chart gives strobe to subject distances for bracketing 1:1, 2:1, and 3:1 extension tube exposures. These are, of course, estimates given an average powered strobe and ASA 64 film. You may have to modify these guidelines slightly for your strobe.

To bracket your exposures, hold the strobe very close to the subject for the first exposure, then move it back twice that distance for the second, and then again as far for the third. One of these exposures will almost always be acceptable. You should always bracket your exposures because the reflectivity of subjects will vary.

BACK SCATTER

Back scatter is a major problem for those who are just starting out in extension tube photography. Unless visibility is less than six feet, it is almost always caused by the photographer stirring up the bottom in the area around the subject.

There are two ways in which the photographer can stir up the bottom enough to ruin an extension tube photograph. One is by simply flailing at the bottom with his arms and legs while trying to stay in one place long enough to take the photograph.

The other cause is less obvious. The photographer will often stir up the bottom immediately around the subject by striking it with the framer. If you must use the framer to entice the subject into a better position, do it carefully. Beating the subject senseless with the framer will not only stir up the bottom, but will usually convince the subject to leave (if it can). It can also bend the extension tube framer, causing it to appear in the photograph. Always approach the subject carefully and place the framer over it as gently as you can.

FRAMING

Framing subjects with extension tubes is not as easy as it might appear. Often minor errors in the positioning of the framer can render the photograph useless. Just as you bracket your exposures, it's a good idea to also bracket your framing.

It's best not to leave the framer on the subject between photographs. For one thing, you will have a tendency to disturb the subject when you advance the film. But, perhaps worse, if you shoot all of your photographs with the framer in one place and it is not placed properly, then all the shots may end up in the round file.

When framing your subjects, draw an imaginary 'X' from the corners of the framer and then try to position your subject at the center of the 'X'. After you shoot, gently lift the framer off the subject, advance the film, then reposition the framer for another shot.

The only additional ingredient for taking good extension tube photographs is composition. Developing the photographer's "eye" or "seeing the photograph before you take it" comes with experience. If you can learn to visualize what both subject and negative space will look like in the photograph before you take it, then you will know whether or not to bother with that subject.

SEPARATION

As with other types of underwater photography, getting good separation is also of major importance in extension tube photography. However, unlike available light and silhouette photographs, the kind of contrast you must rely on is color contrast, instead of shade contrast.

Since you will be using a strobe as the primary light source, and since it is often not possible to photograph macro subjects at upward angles to get open water behind them, your strobe will usually produce an even exposure of both subject and negative space, thus minimizing shade contrast. But if the subject is a different color than the negative space, then your photographs will have color contrast. Color contrast produces excellent separation.

You must learn to look for color contrast when searching for macro subjects. A photograph of a brown anemone sitting on a brown piece of algae will have very little impact when compared to a photograph of a red anemone sitting on a piece of blue coral.

You can often improve the impact of your macro photographs by aiming upwards to incorporate a water background. Since the aperture setting is f-22, the low ambient light will produce almost no exposure on the film, and the background will be black (unless you aim directly up into the sun). Brightly colored subjects against black backgrounds are always exciting.

It is sometimes possible to obtain a blue background in your macro photograph, but it is usually rather difficult. In order to get blue water in the background, the lens must be pointed at a part of the surface where the exposure is f-22. This means you must point the lens directly at the sun (see Photo # 8 & 9). If your aim is not accurate, you will end up with a black background, instead of a blue one, but this can also produce a pleasing effect.

COMPOSITION

Photographs (especially underwater macro) should be simple. Subject material and negative space should be uncomplicated and very easy to recognize. When you look at a photograph (or more importantly, when your friends and publishers look at it) there should be no question as to what the subject is. The subject should reach out and grab your attention immediately and there should be few distractions.

However, underwater macro subjects are often unusual and complicated in form, and the negative space in this kind of photograph is also often extremely complicated. Although you may readily recognize the subject in your own photograph, laymen or even divers who are unfamiliar with that species of marine life may be confused. There are several things you can do to help simplify your photographs.

Subject size in the framer is very important. If the subject occupies a small part of the frame it will often be lost within the complexity of the negative space. You should try to choose subjects that occupy large percentages of your frame, perhaps 50% or more. This way viewers will not have to search the photograph to decide what the subject is supposed to be.

NEGATIVE SPACE

Your choice of negative space will strongly influence the simplicity of your photographs. If your photograph has a complicated negative space and your subject occupies a small part of the frame, viewers may have difficulty determining just what you intended to photograph.

It's acceptable to have secondary points of interest in your negative space as long as these distractions are minor and don't interfere with a viewer's immediate recognition of the subject. As you read the evaluations of the photographs in this chapter, as well as those in Chapters 7 & 8, you will better understand the techniques involved in using negative space effectively.

USING THE STROBE

Extension tube photographs are best taken with a hand held strobe. Usually the Nikonos is mounted on a bracket that has additional mounts for one or two strobe arms. One of these arms should be as short as possible and should be easy to remove from the bracket when you want to take a photograph.

Hand holding the strobe allows you to bracket your exposures by varying the strobe-to-subject distance as well as varying the position of your light. Hand holding the strobe also allows you to easily alternate between shooting vertical and horizontal photographs.

It's very important to remember that when using a strobe you are simulating natural light sources—the sun and the sky. One thing that is always true about natural light is that it comes from above. Although this seems blatantly obvious, it is quite surprising how often photographers light their subjects from below or directly from the side and then wonder why their photographs don't look right.

If you need a good example of the effect of improper strobe positioning, try taking a flashlight into a dark room with a mirror. Stand in front of the mirror and turn the flashlight on underneath your chin. Perhaps you will like the way your face looks with all the shadows in the wrong places, but I doubt it. Remember that your strobe is an artificial sun. Its light should come from above or at 45 degree angles to either side, but never from directly sideways or below. We are used to seeing shadows in certain positions. If the shadows in your photographs are not in these typical positions, then the photograph will be disturbing and unpleasant to look at.

MULTIPLE STROBE LIGHTING

Although one strobe is sufficient to get professional quality results in extension tube photography, two strobes are markedly better. The reason, again, is the simulation of natural light. Natural light comes from two sources: the sun and the sky. The sun produces bright highlights and the sky produces soft shadows.

68

The correct use of 2 strobes will give you photos with softer shadows and more natural looking lighting.

The use of one strobe in macro photography will produce harsh shadows.

Light is different on the moon. There the sun is the only light source since there is no atmosphere. As you may have noticed in photographs taken up there, the resulting shadows are always extremely harsh. Shooting extension tube photographs underwater with one strobe at f-22 produces the same effect. You will get bright highlights, but the areas where the shadows fall will be pitch black.

The use of two strobes will better simulate natural light. By positioning them on either side of the subject at 45 degree angles, you will greatly minimize the harsh shadows. If you position one strobe further away than the other, you will obtain highlights on one side and soft shadows on the other.

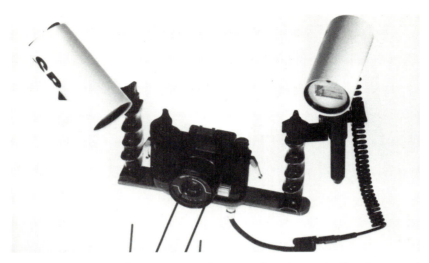

Your extension tube photography can be dramatically improved through the proper use of two strobes, one of which should be hand-held for versatility.

The use of two strobes in extension tube and other kinds of macro photography will significantly increase the number of "keeper" photographs in a roll of film. It will minimize photos lost to backscatter (see Chapter #3) as well as photos ruined because important points of interest were shadowed. In addition, using two strobes will increase the quality of the photographs which you would have kept anyway.

When using two strobes in extension tube photography, one should be hand-held in the left hand and attached to the bracket on the left side when not in use. The other is attached to the right side of the bracket with a movable arm.

There are few, if any, Nikonos brackets currently on the market which have been designed for use with two strobes. However, a few modifications of your own can make most brackets work reasonably well.

STROBE SIZE

The size and power of the strobe you use for this kind of photograph is relatively unimportant. Small strobes work just as

well as large strobes and, in fact, often much better. If a small strobe is only half as bright as a large strobe you simply hold it a little closer to the subject. Thus, power is not very important.

Small strobes have the added advantage of being easier to carry, easier to position, and cheaper to buy (so you can afford two). Attempting two strobe lighting with a pair of large, wide angle strobes can be extremely awkward.

SUMMARY OF PROCEDURES

Choose an extension tube that properly fits the size of the subject that you have in mind. Or, when underwater, search for subjects which will properly fit your frame size.

Once you have found a subject, draw an imaginary 'X' between the corners of your extension tube framer and place the center of the 'X' carefully on the center of the subject. Hold the strobe close for the first photograph. Then remove the frame to advance the film and prepare to bracket your next exposure.

Use the following guidelines for exposure as a place to start: for a 1:1 extension tube try holding the strobe 2 inches away from the subject, then 4 inches, then 8 inches; for a 2:1 tube, try 4 inches, then 6 inches, then 10 inches; for a 3:1 tube try 6 inches, then 9 inches, then 12 inches.

For nearly any strobe you use underwater, these guidelines should provide good exposures. After your first roll of film, you may need to modify these slightly, depending on your own equipment.

If you are using two strobes, your exposures will be the same. Using two strobes instead of one will not greatly affect your exposures.

Before the dive, the camera should be preset at f-22, 1/60th of a second, and minimum focus (see your extension tube manufacturer's specifications for focus settings). If your strobe has multiple power settings, use medium or low power to decrease the recycle time.

Camera: Nikonos II.
Lens: 35mm Nikonos lens
with 5:1 extension tube.
Film: KR 64. Subject
distance: 8 inches. Lens
set at infinity with 3:1
extension tube. Aperture:
f-22. Shutter speed: 60th.
Strobe: two small strobes,
one hand held at upper
left, the other mounted
on bracket at upper right.

Photo #7 *This photograph of an olive sea snake was taken in the Coral Sea by my wife, Michele. Instead of chasing after the sea snake and photographing it with a downward angle as it swam over the bottom, Michele positioned herself at the edge of a reef near where a snake was searching for food. In order to get a level or upward angle on the animal, she waited until the snake approached the edge of the reef and then anticipated where it would go. There she positioned her extension tube framer. Often the snake went in the wrong direction and Michele had to reposition herself. But occasionally the snake swam right where she predicted and into her framer.*

By positioning herself at the edge of the reef, Michele was

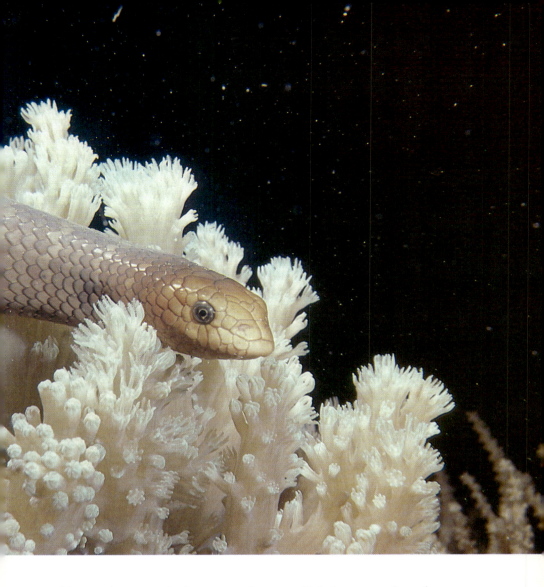

able to photograph the sea snake at a slightly upward angle. Had she been on top of the reef, all she could have achieved would be downward shots. The upward angle created the contrast between the white coral and the dark water background. It also gave the photograph more impact by allowing you to better see the face of the snake and increasing eye contact. By taking the photograph at an upward angle, the snake seems to be looking at you as it swims directly in your direction.

Michele illuminated the photograph with two small strobes. One strobe was hand held at the upper left of the frame, and the other was mounted on the bracket at the upper right.

Photo #8 *This photograph was taken by Michele. She has been specializing in extension tube photography for several years. In this photograph, she used a 1:1 extension tube and a single small strobe. Since she used a 1:1 tube, the size of the image on the 35mm transparency is the actual size of the subject itself. The subject is a spiral gill worm.*

Spiral gill worms are one of the most common macro subjects found in coral reef areas, and thousands of photographs of these tiny animals have been published. But the composition of Michele's spiral gill worm photograph makes this one rather unique. It's not the subject itself that gives this photograph its impact, but rather the way in which she photographed the negative space.

She chose to shoot the photograph vertically and managed to position the sun at the top of the frame, creating a blue water background. This is not an easy thing to do since the lens must be very carefully pointed towards the sun to get this effect. Some of her attempts resulted in missing the sun, yielding more typical black backgrounds (which, though effective, are not nearly as unique as this photograph).

Michele's exposure was made by holding the strobe very close to the subject—about 3 inches. She bracketed the exposures by positioning the strobe as close as possible, then backing off about an inch and a half, and then backing off another inch and a half. Her middle bracket proved to be the best exposure.

Camera: Nikonos. Lens: 35mm. Film: KR 64. Aperture: f-22. Shutter speed: 1/60th. Subject distance: 1:1 extension tube (focus preset at 2.75 feet). Camera angle: straight up. Strobe: one small strobe held directly over the subject.

Photo #9 *This photograph of a kelp plant was also taken by Michele. This time she used a 3:1 extension tube and two small strobes. As in Photo #8, Michele chose an extremely common subject and created a unique photograph by consideration of negative space.*

Again, she managed to create a bright water background in the photo by shooting straight up at the sun. Although she didn't actually get the sun burst in the frame as she did in Photo #8, her results were close enough to produce nice color. The negative space composition makes this photograph unique among hundreds of other kelp shots.

Michele also recognized the obvious vertical orientation of the subject, and therefore shot the photograph vertically. A horizontal photograph of this subject in the same position would have produced awkward composition.

Michele used two small strobes for this photograph, which helped produce even exposure and soft shadows. The strobe on the upper right was attached to her Nikonos bracket and the strobe on the left was hand-held.

The exposure was determined with the hand-held strobe. Michele bracketed by first holding the strobe about 3 inches from the subject, then 6 inches, and finally one foot away. Her second strobe was already positioned at a distance of one foot, allowing it to fill in shadows without greatly influencing the exposure.

Camera: Nikonos. Lens: 35mm. Film: KR 64. Aperture: f-22. Shutter speed: 1/60th. Subject distance: 3-1 extension tube (lens focus preset at 2.75 feet). Strobe: two small strobes.

Photo #10 *This photograph of a Garibaldi was among the first three rolls of film that I ever shot underwater. It was taken with a 3:1 extension tube and a single wide angle strobe.*

In case you think that I simply approached this fish with an extension tube and put it on his face without his knowing it, I'll let you in on a secret. I used a common underwater photographer's trick of bribing the animal with a food handout. I placed the food on a rock and positioned the camera with the extension tube pointing up about 45 degrees, right over the food. When the fish tried to get a bite he would bump into the extension tube. Every time he did I took a picture.

This process took nearly an entire dive. I waited as quietly as possible with the strobe hand-held at the left of the lens (about ten inches from the fish) as the fish worked up enough courage to try for another bite.

I shot 36 exposures during the dive and most of them yielded ludicrous results. Some had only a pectoral fin, some were poorly exposed brackets, some were miserably out of focus, and in some there was no fish at all. But among these I had one "lucky" shot. But, remember what luck is. The more you shoot and bracket with a technique, the better your chances are of getting "lucky".

The negative space in this photo is simply black. This is typical for most extension tube photos that are shot against an open water background. Although it doesn't serve to describe the subject's environment, it is quite effective with brightly colored animals.

Had I taken this photo against a rock, causing the background to be other than black, I would have lost some of the impact. To get clean, black backgrounds, you must shoot at upward angles. Upward angles also produce photographs with more interesting perspectives and increased impact.

Camera: Nikonos. Lens: 35mm. Film: KR 64. Aperture: f-22. Shutter speed: 1/60th. Subject distance: 3:1 extension tube (lens focus preset at 2.75 feet). Strobe: one wide angle strobe placed at the left of the frame about ten inches from the subject.

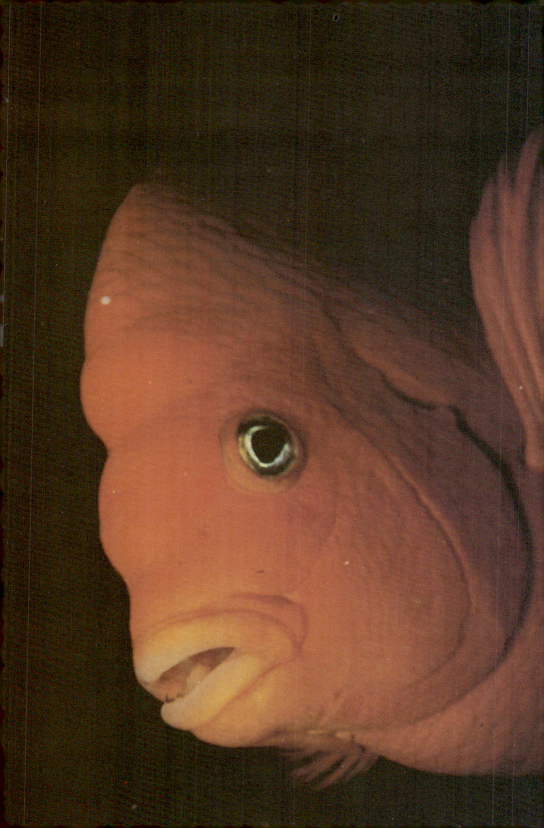

Reflex
Macro
Photography

Chapter 7

There are many similarities

between the photographs in this chapter and those in Chapter 6. Both chapters deal with macro photography, and many of the photographs could have been interchanged between the two chapters without anyone knowing the difference. The only difference between extension tube photographs and many reflex macro photographs is the equipment used to take them.

Reflex macro is done with a single lens reflex camera in an underwater housing and a macro lens. The lens is usually a 50mm macro or 55mm macro, depending on the manufacturer. It differs from other 50mm or 55mm lenses by its very close focusing capability. Depending on the lens and whether you use a flat port or a dome port, the macro lens will focus down to about a 2:1 image (the same frame size as a 2:1 extension tube).

However, the advantage to this sytem is that you are not limited to a 2:1 image. You can choose the distance you wish to shoot from (and thus the frame size), and then you simply focus the lens. You can photograph a three inch nudibranch one moment, then turn around and photograph a two foot long fish! In this way, you have much more versatility, in both your framing and subject selection, than with extension tubes.

Another major advantage to the reflex macro system is that you are able to view the subject through the view finder just as it will appear in the photograph. You will see what the lens sees! This enables you to have complete control over the composition of your subject and negative space.

There are, of course, disadvantages to the reflex macro system as well as advantages. Because you are placing an above

water camera in an underwater housing, the system is much larger and heavier than a Nikonos system. It requires two hands to operate the housing underwater (one for holding on and the other for focusing), so the strobes cannot be hand-held and must be positioned on movable arms which remain attached to the housing.

Another disadvantage to the reflex macro system is that aperture settings must be selected according to subject distances. This means that you cannot simply preset your aperture setting and forget about it, as you do with extension tubes. You must bracket your exposures by altering aperture settings rather than by altering strobe-to-subject distance. And finally, cost. The reflex macro system costs a bunch more than the Nikonos system.

These disadvantages are minor when compared to the benefits derived from the reflex macro system. It gives you the freedom to choose a wide variety of subject sizes during a single dive, and to compose these subjects exactly the way you want to. It allows you to more fully use your imagination and creativity.

WHAT YOU WILL NEED

The first thing you will need is a single lens reflex camera. Not just any one will do, however. You will be better off using one for which an accessory sportsfinder is available. The sportsfinder is a large prism that replaces the regular viewfinder. It allows you to view your image from several inches away (through your mask underwater) and still see the full frame. Both Canon and Nikon make this kind of camera and accessory.

If, however, you use a camera that does not accept a sportsfinder, you may be able to find a supplementary magnifier for your standard reflex viewfinder. Some manufacturers of camera housings produce these types of magnifying lenses. This may not be as effective as a sportsfinder, but it can still be adequate.

After you obtain your camera and sportsfinder, you will need a macro lens (about 50mm). Then you can order your housing. There are many housings on the market for single lens reflex cameras. Some of these are easier to use than others. If you shop

for one in a dive store, ask for a salesman who uses a reflex macro system. If the salesman doesn't own and use one, he will probably be of little help to you. If no one in the store uses a reflex macro system, you might inquire elsewhere.

After you have obtained your camera and housing, you will need a strobe arm and strobe, or a pair of each. At this point you should also get an underwater light meter and a bracket for mounting it on the housing.

STROBES

You will be faced with several decisions when purchasing your strobes. Since the camera housing can also be used with a wide angle lens, you may want to buy a wide angle strobe. Generally, the difference between the large, expensive strobes and smaller, less expensive strobes, is beam angle.

Small strobes put out a relatively narrow beam of light. Beam angles for small strobes average about 50 degrees. This is more than enough to cover the frame of an extension tube photograph or a reflex macro shot, but is insufficient for covering a wide angle photograph. Since you want your strobe to evenly cover your wide angle photographs, you will want to use a wide angle strobe with the wide angle lenses.

The best thing to do is to buy one wide angle strobe for your wide angle photography, and two small strobes for your macro work (a sync strobe and a slave). The small strobes are best for macro photography since they are lighter, easier to carry, and easier to manipulate underwater. However, buying three strobes can be a rather expensive proposition.

As a compromise, you might start with one strobe and work you way up to three over a period of time. You could start with just one wide angle strobe for use with macro and wide angle photographs. Although the use of two strobes will greatly increase the quality of your macro shots, it is still possible to get excellent quality macro photographs with only one strobe.

Later, you could augment your camera system by adding one small slave strobe. Then you could use a large strobe and a

small slave for your macro work. Eventually, you could get a small sync strobe and then you would be all set.

If you are initially limited to buying just one strobe, then you should either buy one large strobe suitable for both macro and wide angle photography; or buy a small strobe and decide to specialize in macro photography (see Appendix for examples of small and wide angle strobes).

VERSATILITY

Reflex macro photography is far more versatile than extension tube photography. It allows you to photograph subjects ranging in size from a few inches to several feet.

The average size reef fish (10 to 18 inches long) is too large to be photographed with an extension tube. In addition, these animals are often rather uncooperative when it comes to placing an extension tube framer around them. So, if you see photographs of fish or other animals in the 10 to 18 inch size range, which are well composed and tightly framed, you can be almost certain they were taken with a reflex macro system. Subjects of these sizes can't be photographed with extension tubes and are difficult to compose with Nikonos wide angle lenses.

Nikon does make a close-up attachment for the Nikonos which produces images of subjects the size of small reef fish. However, it still requires a framer and limits your composition.

EXPOSURE

Unlike extension tube photography, you don't preset your aperture in reflex macro. Instead, you rely on guide numbers, Guide numbers tell you what aperture to use depending on the subject-to-strobe distance. Before taking a reflex macro photograph, you must estimate the subject-to-strobe distance and then set the proper aperture setting.

For my reflex macro system, which incorporates two small strobes, I use f-16 at minimum focus to one foot, f-11 at about 18 inches, f-8 at about two feet, and f-5.6 at about three feet. Of

course, I bracket my exposures around these four numbers so that at one foot I would shoot f-22, f-16, and f-11. These guide numbers will probably work well for your system, although you may need to modify them slightly, depending on the strobes you use and the water conditions in which you are diving. Adding a second strobe will have little or no influence on your exposures.

BALANCING EXPOSURES (or FILL LIGHTING)

On a sunny day in tropical water at a depth of twenty-five feet, your available light exposure will usually be f-8 for ASA 64 film and a shutter speed of 1/60th. This is, of course, an average exposure and will sometimes be lighter or darker than f-8. However, it means that when using a reflex macro system at distances of 18 inches to three feet, your guide number exposure will nearly match the available light exposure. A photograph in which the available light exposure is the same as the strobe exposure is said to be "balanced".

In a balanced photograph you have a brightly colored subject as well as a properly exposed environment behind the subject. Most of the time you wouldn't suspect that artificial light was used at all (because the colors look so natural); except you know that without the artificial light the colors wouldn't be there. The strobe is not used to increase the exposure, but simply to paint in colors and fill in shadows.

Balancing you exposure gives depth to your photograph. The picture not only describes the animal in accurate color, but it also tells something about the habitat in which the animal lives. A balanced photograph "places" the subject within the environment.

In conditions of high ambient light, it is often difficult to avoid balancing your photographs. In fact, in bright conditions your available light reading (from the light meter that I suggested you purchase) may exceed the guide number. If this is the case, the available light reading takes precedence. If the available light reading is f-11 and the guide number is f-8, then you should use f-11 (and bracket, of course). Instead of serving to increase the ex-

posure, the strobe will simply fill in the colors left out by the available light. But available light will make the primary exposure.

In deeper water or in diving areas where the water is not as bright as in the tropics, you can still balance your exposures much of the time. This is done by angling your camera upwards at the subject until your light meter reading matches your guide number. Even in dark California waters, you can balance exposures if you use upward angles.

HOUSING PORTS

Most camera housings are available with either a dome port or a flat port. A dome port is best for wide angle photography. However, for macro photography there are advantages to both dome ports and flat ports. If you are photographing small subjects you are better off with a flat port.

Due to refraction, the flat port magnifies your subjects by nearly 30%. If a dome port gives you a 3-1 image at minimum focus, then a flat port will give you a 2-1 image. So, for most of your macro photography, you will find the flat port more versatile since it enables you to successfully photograph smaller subjects.

If, however, you want to photograph a relatively large animal (perhaps a 2 foot long fish), you will have to shoot from further away with the flat port than with a dome port. At distances greater than three feet, your strobes will have lost most of their effectiveness and the image begins to scatter. Thus, for relatively large animals you will be better off with the dome port.

Perhaps the best way to start is with the dome port. This way you can do both wide angle photography and macro. Later, when your budget recuperates, you can buy a flat port.

STROBE POSITION

Your strobe (or strobes) should be attched to your housing with a movable arm (or arms). Ball joint arms or flex arms are usually best. There are lots of strobe arms on the market, but

most of these have very limited range of motion. These will suffice if you are using a Nikonos and plan to remove the arm. However, with a reflex macro system the arms must stay on the housing and they must be movable enough to photograph small subjects directly in front of the lens as well as subjects three feet away.

Remember that when you position your strobes you are trying to simulate light from the sky. If you are using one strobe, it should be positioned high above the subject and slightly off to one side. If you are using two strobes, you should have them on either side of the subject aimed at 45 degree angles downward. To create soft shadows on one side of the subject, one of these strobes should be positioned closer than the other.

The use of two strobes in underwater photographs can usually be determined by inspecting the shadows in the picture. Photograph #11 (pp. 90-91) is a good example. If you inspect the shadow underneath the fish's chin closely, you will notice that there are actually two shadows there. One is very dark, directly below the chin where neither strobe could reach. The other shadow, to the right of the dark one, is softer. This soft shadow was created by one strobe and filled in by the other.

Obviously the strobe on the left was positioned considerably closer than the strobe on the right. The goal in this case was not to entirely eliminate shadows; but rather to soften the shadows produced by the primary strobe. This was done with fill light from the second strobe (the one on the right).

The orientation of the fish greatly influenced which strobe was to be primary (closer) and which was to be secondary (further). Had the strobe on the right been my primary strobe, then there would have been a large shadow to the left of the fish. This would have placed the animal's face in shadow rather than in highlight.

SUMMARY OF PROCEDURES

Before approaching your subject, decide how you would like to frame it and then pre-position your strobes. Switching between vertical and horizontal frames will require considerable strobe position adjustment, and it is better to do this before getting close enough to disturb the subject.

After you approach the subject, frame it in the viewfinder, giving careful consideration to subject size and negative space. Inspect every square millimeter of the frame before you decide to take the photograph.

Choose the proper aperture setting based on the strobe-to-subject distance. Or if the ambient light is high, take a reading on the water behind the subject and compare that to the guide number, using the higher of the two.

If ambient light levels are not high but you still wish to balance exposures, choose the proper guide number for the strobe-to-subject distance, then angle your camera upwards at the subject until the light meter indicates the same exposure. And, of course, remember to bracket your exposures.

Camera: Nikon F2 in a housing with a flat port. Lens: 55mm Micro Nikor. Aperture: f-8. Shutter speed: 1/60th. Subject distance: 18 inches. Film: KR 64. Camera angle: slightly down. Strobe: two small strobes. One upper left at 18 inches; the other upper right at 24 inches.

Photo #11 *This photograph of a rockfish was taken at night on Tanner Banks, a seamount about 100 miles off the coast of San Diego, California. The colors on the bottom there are extremely brilliant. I wanted to photograph these colors, but needed a subject to provide a central point of interest. This small rockfish filled the bill.*

I tried to frame the rockfish with as much of the bottom color as possible, without distracting from the immediate recognition of the subject. To do this, I framed the fish so that his length occupied a little over half the frame. Had the rockfish appeared much smaller in the photograph, the composition might have been confusing.

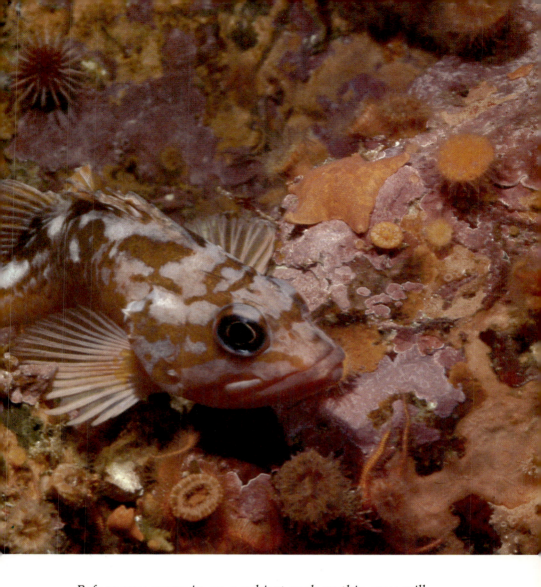

Before you move in on a subject such as this, you will want to notice the subject's orientation and then position the strobes so that the side facing the lens will receive the primary light. If you are using only one strobe, this is especially important.

Being able to perfectly position your subject within its negative space is one of the major advantages of a relfex macro system. You can choose the exact framing that you want (by moving in and out) and can then carefully inspect every square millimeter of the frame for negative space composition before you shoot.

Photo #12 *This photograph of an anemone was taken in the northern Sea of Cortez in Mexico. These anemones are common there and, though not particularly colorful, they are quite beautiful.*

In order to accentuate the beauty of this anemone, I spent my dive searching for an individual within an exciting negative space. I wanted to find either a uniform, brightly colored background to contrast with the simplicity of the white anemone, or an anemone that could be photographed against a black background. This anemone attached to the gorgonian coral produced my best shot.

As I searched, I passed hundreds of beautiful anemones without giving them a second glance. I was not searching for anemones, I was searching for negative space.

I photographed the anemone vertically because the gorgonian was oriented vertically. I used a slight upward angle to make sure the background behind the gorgonian would be dark.

Camera: Nikon F2. Lens: 55mm Micro Nikor. Film: KR 64. Aperture: f-11. Shutter speed: 1/60th. Camera angle: slightly upward. Subject distance: 10 inches. Strobe: two small strobes, one at upper right and the other at upper left at equal distance.

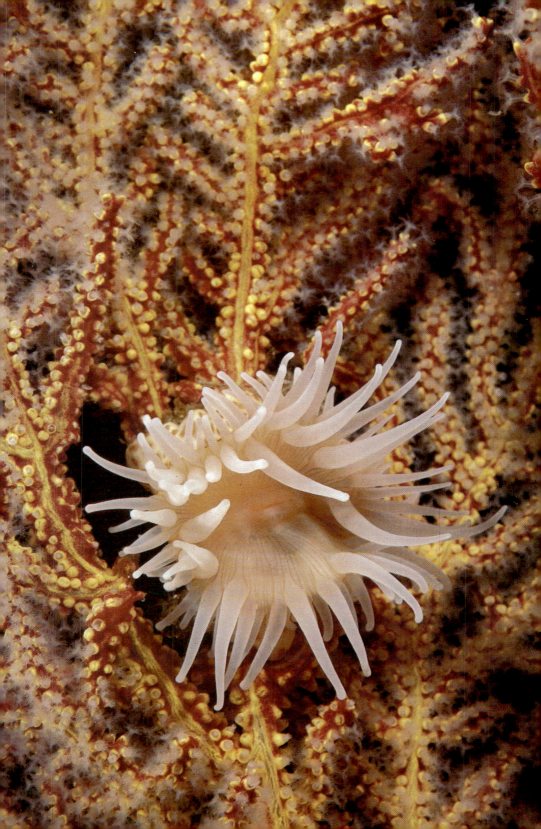

Photo #13 *This photograph was taken at night in the waters off Socorro Island, Mexico. We were anchored in a small bay where the diving was not very exciting. During the night dive, all we saw were thousands of sea urchins. So, I tried photographing sea urchins in a wide variety of ways. I was pleasantly surprised with the effect in this photograph.*

I used two strobes in this photograph. I positioned one of them above the camera, aimed at the sea urchins. The other (the slave) I removed from the camera housing and set down behind the rock three feet away, pointing directly at the urchins.

The slave strobe produced the delightful effect of illuminating the translucent spines of the urchins. The other strobe filled in the features of the rock and the bodies of the urchins.

You will notice that there were great amounts of suspended particles in the water at the time this photo was taken. Yet, backscatter directly in front of the lens was minimized by positioning the fill strobe high above the lens, instead of directly over it.

Backlighting with your slave strobe can be effective in daytime also. However, a common mistake is to place the slave strobe much too close to the subject. If your primary strobe is one foot away, then your backlight strobe should be at least twice as far (or about 2 feet away) since it is pointing directly at the lens.

Camera: Nikon F2 in a housing with a flat port. Lens: 55mm Micro Nikor. Film: KR 64. Aperture: f-11. Subject distance: 18 inches. Shutter speed: 1/60th. Camera angle: upward about 20 degrees. Strobes: two small strobes. One at the upper center about 14 inches from urchins; the other directly behind and three feet from the rock, aimed directly at the camera.

Photo #14 *This is one of hundreds of photographs I have taken of this species of nudibranch, and I consider it one of the best. It's not the nudibranch in this photograph that makes it exceptional, but rather the negative space.*

There are three aspects of the negative space in this photo that are noteworthy: the rock, the water, and the small gorgonian. The rock was a matter of luck. The nudibranch just happened to be crawling on a green rock that very nicely contrasted with its purple and orange colors. The water color was not a matter of luck. I wanted blue or green water color in the background to give depth to the photograph.

The water color not only gives the photograph depth but it also lets you know a little more about where this animal lives. To get this effect I had to shoot at an extremely steep upward angle. In fact, since the aperture used was f-16, I had to shoot nearly straight up.

The photograph may not look as if it were taken straight up because your mind is used to looking at things from the side and assumes that this photograph was taken that way. Also, the shadows created by the strobes make the photograph look as if it were taken from the side. Having green water in this photograph is a small detail, but it is a "plus" when compared with other more typical nudibranch photographs.

The gorgonian was not there due to pure luck either. After positioning myself below the nudibranch, I waited until it had crawled past the gorgonian coral to an interesting position. The gorgonian provided a nice secondary point of interest.

The body position of the animal was also very important. The fact that it was coming toward the lens, not directly but at an angle, is no accident. The photograph would have lost considerable impact had the nudibranch been going away from the lens or even traveling sideways. The subject's body position will be more carefully discussed in the next chapter on Portraits.

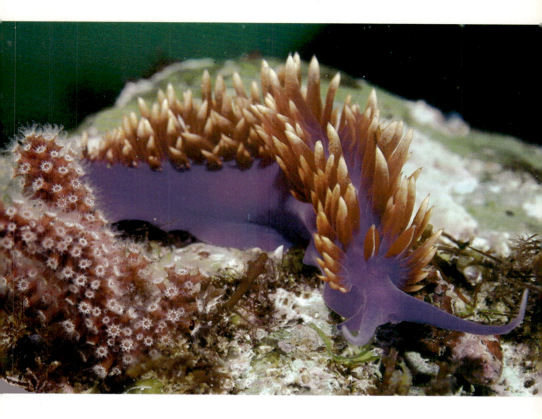

Camera: Nikon F2 in an underwater housing with a flat port.
Lens: 55mm Micro Nikor. Film: KR 64. Aperture: f-16. Shutter
speed: 1/60th. Subject distance: minimum focus—about 5 inches.
Camera angle: almost straight up. Strobes: two small strobes, one at
upper left 8 inches away, the other at upper right twice as far away
(about 15 inches).

Marine Wildlife Portraits

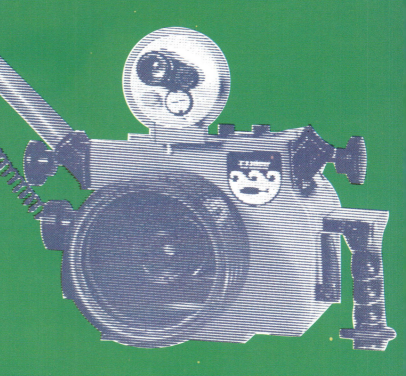

Portraits of marine wildlife

may be taken with all kinds of equipment, from extension tubes to wide angle lenses. And there are many wildlife portraits in this book besides the ones in this chapter. This chapter is not about specific equipment or techniques. Instead, it is about the philosophy behind composing wildlife portraits. You may think that the high impact photographs of marine wildlife displayed in magazines are the result of pure genius. Well, perhaps some are. But more often than not, they are the result of competent photographers using rather basic concepts of composition.

There are many ways to photograph animals. There are identification photographs showing a side view with all of the animal's parts in proper proportions. There are photographs of animals in action (feeding, schooling, or swimming), and there are those photos which picture the animal in its habitat (placing equal emphasis on both the animal and its environment). But the most common and perhaps the most striking type of creature photograph is the portrait.

The portrait photograph is an attempt to capture not only the way the animal looks, but something of its personality as well. Its goal is to capture an image that says something about the animal's character and temperament. It is a photograph that captures expression.

APPROACH

There are some important concepts which influence the impact of wildlife portraits. The animal in the photograph should

100

seem to be aware of the viewer, and its expression should communicate some aspect of its personality. In order to achieve this, the photographer should approach the animal as if attempting to carry on a conversation with it. Although this idea may seem a little foolish (if not a whole lot foolish underwater), the concept is very important.

A portrait should "speak" to you, and there are several unwritten rules about conducting a conversation. You do not converse with a person while looking down on top of his head, nor while looking at the back of his head, nor do you converse with someone while inspecting his tail (if people had tails), nor while he's walking (or swimming away from you.) And you do not talk to someone from clear across the room. When you conduct a conversation, you should be face to face, close, and looking at the eyes and mouth.

The eyes are of primary importance. When you look at the photograph, the first thing you will notice will be the animal's eyes. For this reason, the eyes must be very prominent in the photograph. The eyes must also be the point of critical focus. If the eyes are soft, then the photograph will be unpleasant to look at and must take its rightful place in the round file.

The depth of field must be manipulated so that the eye and everything forward of the eye (like the nose and mouth) is in focus. If the eye is sharp, but the face of the animal forward of the eye is soft, the softness will be very distracting. The area behind the animal's eye can go out of focus without much loss of impact. Generally, getting the eye and facial features forward of the eye in focus is not a very scientific process. You simply focus on the eye, and depth of field will usually take care of the rest.

CAMERA ANGLE

Another very important concept is choice of camera angle. It is a well known fact that tall people have a psychological advantage over shorter people in conversations. Teachers and ministers on raised podiums have extra power over their audience simply because they are situated above them. This concept can be used in animal portraiture.

101

If you want the photograph to have added power and impact (and why wouldn't you) then make the animal appear to stand above you in the frame. If the animal is above you in the photograph, then it appears to be a towering monster which might gobble you up at the slightest provocation. But if you are above the animal looking down at it (perhaps a far easier angle to get), the creature becomes just a small fish that you could easily step on.

BODY POSITION

The angle of the animal's body is also important. It is better not to photograph the animal absolutely straight on, although this approach can be effective at times. You are usually better off framing the animal at an angle of about 45 degrees. This will allow you to see most of the animal's body, making the subject more recognizable and less confusing, while still keeping the face in a position of forward prominence. Even at very close range, a slight angle often adds depth to the photograph.

LIGHTING

Lighting can be a problem in portraits. Since most portraits are taken at close range, artificial light is often used to allow small apertures and increased depth of field. The use of one strobe will generally illuminate one side of the animal's head while leaving the other in a very harsh shadow. Or, if the strobe is held directly above the subject, there will be a very large dark shadow below the animal's chin. For this reason, portraits taken at close range with extension tubes or a reflex macro system are best taken with two strobes.

Each strobe should be positioned to one side and above the animal so that light comes down at 45 degree angles on either side of the creature's face. One strobe should be powered down or moved further away than the other so that the brightness ratio between the two strobes is about 2:1 at the subject. This will produce soft shadows on one side of the animal's face and highlights on the other.

In situations where there is plenty of ambient light (as in the tropics) or where the animal is large enough to allow the use of a wide angle lens, one strobe can be used as a fill light. The fill light will fill in colors and remove shadows on one side of the face, while ambient light softens shadows on the other. In this case, a light meter should be used to determine the ambient light exposure. Then strobe power (or strobe-to-subject distance) should be manipulated to balance the two exposures.

SUMMARY OF PROCEDURES

Before approaching the subject, take a moment to inspect the animal from a distance. Decide how you want to approach and frame it before you move in. Then pre-position your strobes so that one will be on either side of the animal's face (with one a little further away than the other) pointing downward at about 45 degrees. Next, select your aperture.

Then move in. Get close enough for the animal to fill at least half the frame. His body should be face first and at about a 45 degree angle away from the lens. Position yourself as low as you can and aim at an upward angle if possible. Make any minor adjustments to the strobe positions that might be necessary. Focus (or position the extension tube) so that the eye and the face forward of the eye will be in focus. Then take the picture. Bracket your exposures. Bracket your camera position.

Camera: Nikonos.
Lens: Nikonos 15mm.
Film: KR 64. Aperture:
f-8. Shutter speed:
1/60th. Subject distance:
5 feet. Strobe: one large
wide angle strobe set at
low power and held to
the left of the frame.

Photo #15

A portrait is not necessarily a photograph of just an animal's face. As with this picture of a mako shark, a portrait can include the entire animal. It's the position of the animal's body and the prominence of the face that gives a portrait animation and impact.

Although it's much easier to take photographs of animals as they swim by or swim away, it's the approaching angles which will have the most impact. It's best to wait for the animal to come your way. It doesn't have to be coming directly at you (in fact direct head on shots are sometimes a little confusing), but it should be coming at some angle in your direction.

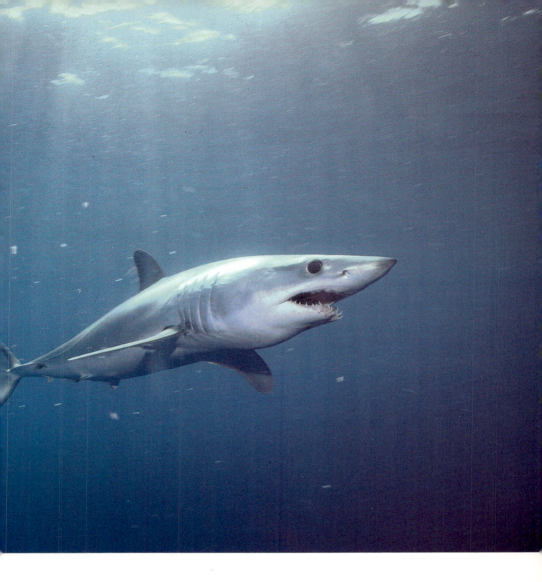

This photograph was taken with a Nikonos 15mm lens focused at five feet and a wide angle strobe. It could be argued that a faster shutter speed and no strobe would be a better way to photograph a mako shark since it's a fast moving creature. It's true that a 60th of a second is a slow shutter speed for such an animal. However, the mako stayed around our shark cage for hours allowing me plenty of opportunities and I knew that the strobe would add a very small amount of subtle color to his photograph in a very strategic area—the mouth. The color in the mouth and the detail of the teeth make this a superior shark photograph. Of course, I bracketed many times, and discarded the photographs that were out of focus.

Photo #16 *This portrait of a scorpion fish was taken at Isla Benedicto in Mexico. I wanted to get as close as possible in order to capture the incredible detail and complexity of the animal's face.*

Because I took this photograph at a depth of 130 feet, I had no idea what the true color of the fish was, though I suspected it was full of warm colors. The bright red result was a startling surprise. Again, I used a reflex macro system to get this photograph. However, a similar one may have been possible with an extension tube system.

Had only one strobe been used in this photograph, there would have been numerous harsh shadows behind each of the skin projections. Also, much of the detail on the chin would have been lost by having to place a single strobe above the animal's head. Two strobes greatly improve this photograph.

The camera angle is ideal in this photograph. Despite the fact that the animal is on the bottom, I managed to get the lens below him, if only slightly. Although this camera angle was not enough to balance with the background water color (this is especially unlikely at 130 feet), it was sufficient to give the photograph impact and to increase the power of the animal's character. This is the primary reason for shooting portraits at upward angles.

Getting an upward angle is not always easy. I found the fish sitting on a rocky bottom in a small depression. Instead of wasting film shooting a few exposures of him in that position (not to mention limited time at 130 feet), I disturbed the animal in hopes that he would land on a rock which would enable me to get below him for an upward angle. After a couple of tries, the fish cooperated by landing on the top of a nearby rock, resulting in this opportunity for a successful photograph.

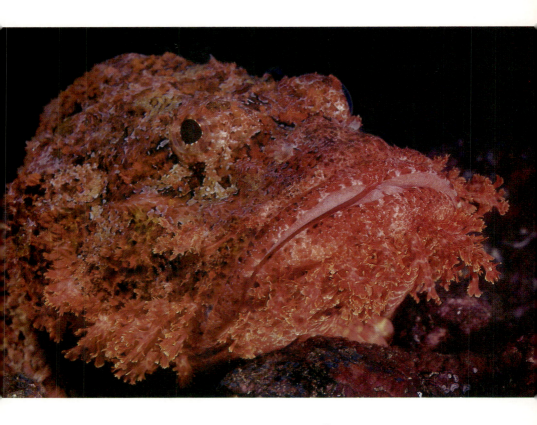

Camera: Nikon F2 in a housing with a flat port. Lens: 55mm Micro Nikor. Film: KR 64. Aperture: f-16. Shutter speed: 1/60th. Subject distance: one foot. Camera angle: slightly upward. Strobes: two small strobes set to either side at 45 degree angles and at about equal distance.

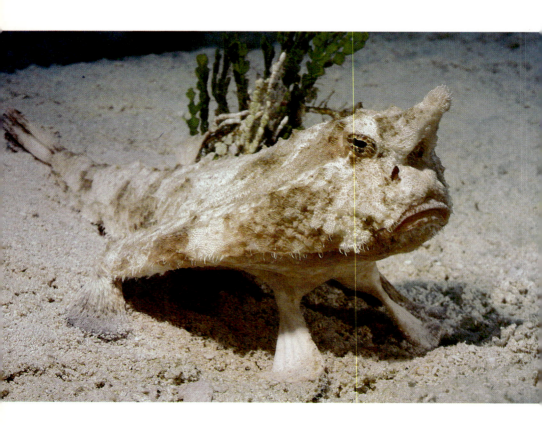

Camera: Nikon F2 in a housing with a flat port. Lens: 55mm
Micro Nikor. Film: KR 64. Shutter speed: 1/60th. Aperture: f-11.
Subject distance: one foot. Camera angle: slightly downward.
Strobes: two small strobes on either side at 45 degree downward
angles. The left strobe was about 14 inches from the subject and the
right strobe was about 20 inches away.

Photo #17 *This strange looking creature is a batfish. I photographed him on the Bahamas Banks. As in Photograph #15, the entire animal's body is in the frame. However, the face of the batfish is in a position of forward prominence. The angle of the animal's body is about 45 degrees from the lens. This allows for most of the body to be visible and in acceptable focus, with the face still in a prominent position.*

This body position is ideal for most portraits of marine animals. Had the photograph been taken from a more head on position, the body would not have been visible and the photograph might have been confusing because the viewer could have difficulty deciding just what it is that he is looking at. Had I aimed from a more side on angle, the photograph would have lost considerable impact.

The camera angle here is slightly downward. Only slightly. It's not that I chose this camera angle over an upward angle, it's just that the ocean bottom was in the way. The camera housing was actually laying flat on the sand. To improve the camera angle a little I even tried digging a shallow hole for the camera housing to sit in. But this is not easy since the process kicks up sand and often frightens away the wildlife. In situations such as this, it may not be possible to get below the subject. Just get as low as you possibly can. Every millimeter will help.

The lighting in this photograph is ideal. I used two small strobes, and the high ambient light levels effectively filled in the shadows that the strobes couldn't reach. In this case, balancing with the background was easy. The ambient light reading was f-11, so all of the photos I shot were bracketed around that f stop.

If you take a close look at the shadows under the batfish's body, you can see shadows where neither strobe reached. You can also see shadows left by one strobe which were filled in by the other. The large blue shadow on the sand to the right of the fish was a small depression in the sand which neither strobe could reach. It was filled by blue ambient light.

Photo #18 *This fish is called a Sarcastic Fringehead, and was photographed during a beach dive in the La Jolla Submarine Canyon. He is about fourteen inches long and lives in a pipe protruding from the bottom. As the name implies, the fringehead is a pugnacious little brute who will viciously attack anyone (even divers) who approaches his territory.*

I took the photograph with a reflex macro system (as you should be able to tell by now) utilizing two strobes. I framed the photograph vertically since the pipe and the fish were oriented in that direction. Every time I moved in to take a shot, the fringehead would dash out of his pipe to attack my fingers. This is much less disturbing than you might guess, since the little fellow has no teeth to speak of, and can only gum you up a bit. But I wanted a photograph of the fish in his home rather than free swimming.

To achieve this, I focused on the pipe and then backed off to wait for the fish to return. Then, I moved in quickly and snapped a photo before the fringehead could rush out and attack me.

The camera angle in this situation greatly increases the impact of the photograph. I aimed from well below the fish with about a 45 degree upward angle. This allows the fish to "look down" on the viewer in the photograph. It gives the photograph power and impact. His open mouth was an added bonus.

The upward angle in this photograph also improves the negative space by producing a blue (balanced) background instead of a black one. Although the black background might also have been effective, I believe the blue creates a better photograph. The presence of kelp in the upper right hand corner adds color and serves as an interesting secondary point of interest. I tilted the frame to that side slightly to get as much of it as possible without distracting from the subject.

Camera: Nikon F2 in housing with flap port. Shutter speed: 1/60th, aperture: F11. Subject distance: 18 inches. Camera angle: 45 degrees upward. Strobe: two small strobes; one at upper right about 16 inches from the fish, the other at upper left, 24 inches from the fish.

110

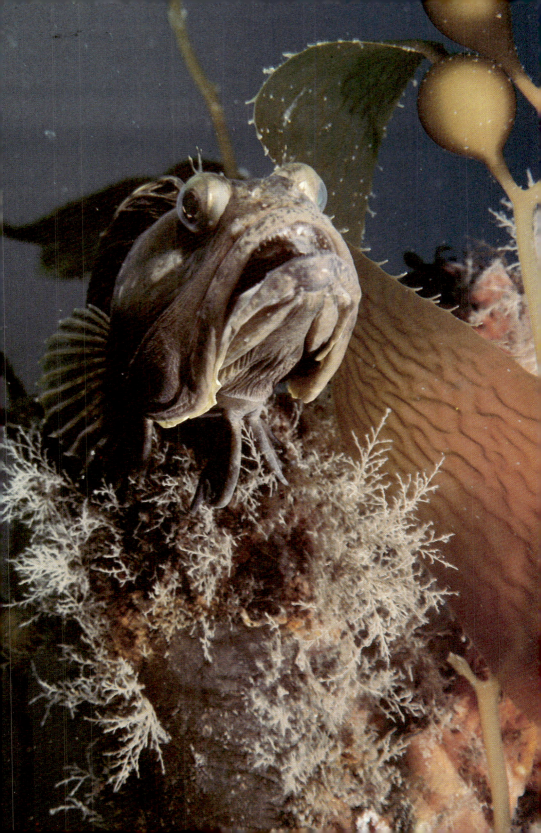

Photographing People

Chapter 9

Divers
are perhaps
the most

common subjects for under-
water photographs. However,
they are not easy subjects to
photograph successfully. There are a
number of reasons for this. When you take a photograph of a fish
and the color is slightly off, or a fin is in the wrong place, or the
eyes are looking at you in an odd way, it usually makes no dif-
ference. Nobody knows what the colors are supposed to be (even
the photographer) or just what the fish should be doing with his
eyes and fins.

But it's different with people. If the skin tones are strange, or
the eyes are crossed, or the arms and legs are positioned in a
slightly awkward fashion, everyone will notice. Unfortunately,
divers often look like this. You will find yourself discarding many
photographs that are technically perfect, except that the diver
looks like he is being shocked with an electric cattle prod.

COMPOSITION

Despite these difficulties, good diver photographs are still a
dime a dozen. In order to take one that is really valuable you
need to do one of two things, and hopefully both. You need to
photograph the diver doing something interesting, and you need
to include good negative space.

Photographing the diver doing something is important if you
want the picture to say something more than "Hi, Mom". Captur-
ing good negative space is important because photographs of
divers are always pictures of "divers in the underwater environ-
ment" and not just pictures of "divers". In most cases, the
negative space in diver photographs is more important than the

114

subject, since the subject is just another diver (certainly not an endangered species).

Divers are large creatures and they don't often hold still long enough to be photographed. You will need at least two things in order to be successful. You will need a wide angle lens and you will need a cooperative model. You should find a dive buddy who is willing to act as a model. Then plan out exactly what kinds of photographs you want, and review the hand signals you will use. You should also brief your buddy on two important things: the dangers of stirring up the bottom, and what he should do with his eyes.

When you look at a photograph of a diver, the eyes will be the first thing you will notice (assuming they are visible, of course). The eyes will tell you what the diver is seeing, thinking and feeling. Therefore, what your model does with his eyes is critical. If the model is looking at the lens, the photograph will usually say simply "Hi, Mom". It is best if the model looks almost anywhere else but at the lens.

However, if you want the diver's face to be in the photograph, the model's face mask should be turned almost directly at the lens; not the diver's eyes, just the mask. If the mask is turned away from the lens at too great an angle, water refraction will grossly distort the face.

So where should the diver's eyes be looking? At what he is doing, of course. Hopefully, you will photograph the diver doing something interesting. If the diver is just looking off into blue water, the photograph will say "diver underwater". Certainly this is not always bad, and if the negative space is spectacular, it can be very effective. But the photo will be more effective if the diver is engaged in some interesting activity within that spectacular environment.

NEGATIVE SPACE

Since negative space is so important to successful diver photographs, it is important to balance the exposures. In bright tropical waters, this is seldom a problem. Take a light meter

reading on the water behind the subject and then fill in colors and shadows with your wide angle strobe.

In darker temperate waters ambient light is very low. Often the strobe can overpower the available light, creating an under-exposed negative space surrounding the diver. Most wide angle strobes are powerful enough for general underwater photography. In low ambient light conditions, however, it is very useful to have a strobe that can be powered down so you can balance your exposures.

When photographing in situations of low ambient light, you can increase your available light reading by using upward angles. If you know that your strobe will give you an f-5.6 exposure at a subject distance of four feet, then you can get below the subject and increase your upward angle until the light meter reads f-5.6. In dark temperate waters, this is often the only way you can balance your exposures.

Negative space becomes progressively more important to the photograph when the diver occupies a small portion of the frame. Photographs in which the diver is swimming in the distance are really photographs of the environment, with the diver as a primary point of interest. In these photographs, your care in selecting and composing negative space is extremely important.

SKIN TONES

Due to color absorption, diver's skin tones often appear unrealistic. All the other colors in the photograph may seem fine, even if they are slightly off. But we are so familiar with what proper skin tone looks like that, if it is off a bit, it will be very noticeable.

There are a few things that can be done to improve skin tones. The most practical of these is simply to get close. Photographs of divers with exceptionally realistic skin tones are taken from very close range, usually from less than six feet away. In order to photograph from such close range and still get the en-tire diver with lots of negative space in the photograph, you must use a very wide lens. 21mm, 20mm, 15mm and 16mm lenses for

Nikonos cameras, or cameras in housings, are all suitable choices for diver photographs.

Getting close to the subject is the tactic I use in order to get realistic skin tones. In addition, I normally use Kodachrome 64 film, which produces enhanced warm colors (oranges and reds), rather than using Ektachrome, which produces enhanced blue shades.

Some photographers use a CC30R color correction filter to warm skin tones when photographing divers. This is a practical idea, and is especially effective if you decide to use Ektachrome film.

DRESS

The diver's appearance is an important consideration when choosing a model. Often divers look like they were dressed by someone who had a sense of humor (black wet suit, garden gloves, athletic socks, and a life vest borrowed from under the seat of an airplane). It is a great advantage to have a model who wears a colorful suit, gloves and compensator. However, I think that dressing your model like Spiderman is an overkill.

It's best to use a little taste and good color coordination. It is also helpful if the model's mask allows most of his face to be seen. Clear silicone masks are ideal, since they allow the strobe to illuminate the face from nearly any angle.

BODY POSITION

All divers look awkward at times. Unfortunately, it seems that they look most awkward when you are trying to photograph them. There are a couple of things you can instruct your model to do in order to minimize the problem.

When photographing models on the ocean floor, have them kneel or stand in an upright position. Although it is often easier for divers to do things from a horizontal position, it looks unnatural and awkward unless they are swimming. When doing things with their hands, have them keep their hands low, so that their face is unobstructed.

When photographing a diver swimming through a scene, it is often tempting to have him stop in the area where you want to photograph him. But when a diver stops kicking, his fins begin to do rather odd things, often sticking out at unnatural angles. Your model doesn't have to swim through the frame at a fast pace, but he should continue kicking in order to keep his fins moving and to maintain a natural appearance.

Your model's arms should be kept close to his body. Sometimes models seem to think that stretching out their arms and legs like a sky diver will make the photograph more interesting. It doesn't. Instead, it makes the photograph look contrived.

EQUIPMENT

To photograph people underwater you will need a camera system with a wide angle lens. Various manufacturers make 21mm, 20mm, and 15mm lenses for use with the Nikonos camera. The 28mm lens will provide acceptable results, but it can't compete with the results you'll get by using wider lenses.

There are a variety of wide angle lenses to use with a housed camera and dome port, including a 20mm, 24mm, 17mm, 18mm, 16mm and more. You are better off with a lens which offers a picture angle of about 85 degrees or greater.

Small strobes have beam angles that cover about 50 degrees or less, and their effective range is about four feet. To cover your wide angle photographs of divers, you will need one of the larger (more expensive) wide angle strobes. It should have a beam angle of at least 90 degrees (wider if possible). It should also have variable power, so that you can balance exposures in low ambient light conditions. In addition you should have a light meter.

SUMMARY OF PROCEDURES

Choose a colorfully and tastefully dressed model. Spend some time instructing him how to model for you (what you want him to do, and what you don't want him to do). Discuss activities which he can be involved in for the photograph, like feeding fish,

handling marine life, or acting as a photographer. Review the body positions you want him to use. Remind him to always position his mask toward the camera, if possible. Also discuss what you want him to do with his eyes.

Once underwater, look for an area where the negative space is exciting. Position your model within the negative space, so that you can aim from a position that gives you good separation. This usually means an upward angle.

If you want realistic skin tones, move in as close as you can while still being able to frame the diver's entire body. Cutting off part of the diver's body, such as his legs, detracts from the photograph. Take a light meter reading on the water behind the diver, and choose a strobe power setting (or estimate the strobe-to-subject distance) that will balance the exposure.

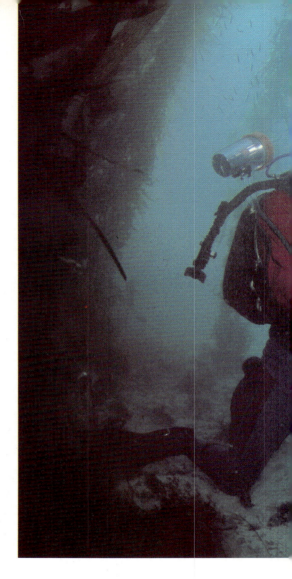

Camera: Nikon F2 in a housing with a dome port. Lens: full frame fisheye 16mm. Film: Ektachrome 64 (specified by my employers for that particular assignment due to its duplication properties when producing film strips). Aperture: f-4. Shutter speed: 1/60th. Subject distance: 3 feet from the lobster. Camera angle: 20 degrees upward. Strobe: one wide angle strobe, set at low power and mounted 20 inches above the lens.

Photo #19 *In this photograph the divers, Marty Snyderman and Terry Nicklin, are bagging a 12 pound lobster. This activity makes the photograph interesting. The negative space in the photograph is not particularly exciting, but the presence of kelp in the upper left of the frame helps place the location of the subjects in California water.*

The equipment used was a Nikon F2 with a 16mm full frame fisheye lens. The distortion produced by a full frame fisheye is almost always apparent in topside photographs, because straight lines at the edges of the frame appear curved in the photograph. Underwater, however, there are few

120

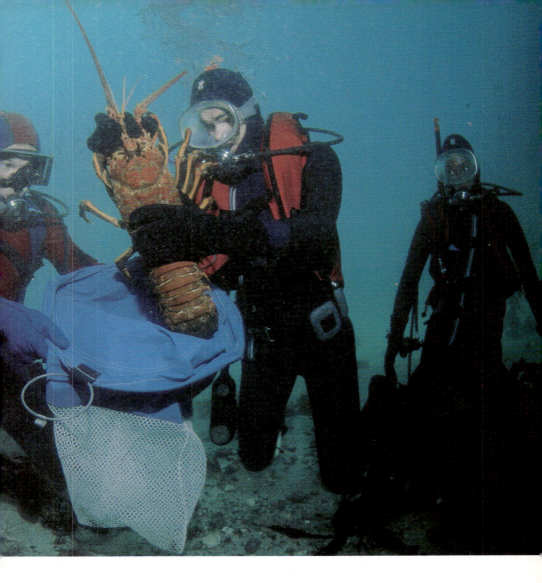

straight lines, and often this distortion is almost unnoticeable.

In this photograph, however, the kelp appears to be curved, and the diver at the right edge of the frame is distorted. However, this distortion is not very distracting. Minor edge distortion in an underwater photograph may provide a clue that a full frame fisheye lens was used.

Light levels in the kelp were extremely low. In order to balance exposures, I used my wide angle strobe at low power, and held three fingers over the front of the strobe to further reduce light output. I also used a 20 degree upward camera angle with an aperture setting of f-4.

Photo #20 *The diver in this photograph is Marty Snyderman. He's holding a broken sea urchin, which he has used to bait the brightly colored garibaldi fish. He's also holding a small slave strobe, which he is aiming at the fish to accentuate their color. To the layman, this strobe would probably appear to be a hand light.*

Marty has perched himself on top of a rock, which has allowed me to get well below him, in order to use a 30 degree upward camera angle. Most of these details were pre-planned before the dive.

The subject in this photograph is "a diver with fish". Marty's interaction with the fish helps make the photograph interesting. Without the fish, it would be just a nice photograph of Marty, and would be of little interest to anyone, with the possible exception of his mother.

The photo was taken with a Nikon F2 in a housing with a dome port. The lens was a Nikon 16mm full frame fisheye, which allowed me to get extremely close to the subjects. Since this lens has a picture angle of 170 degrees, I was able to take the photograph at only four feet away from Marty's face. This close range allowed me to get excellent colors and realistic skin tones.

The strobe I used was a large, wide angle strobe, set at low power. Had the power setting been high, the strobe would have overpowered the available light reading, preventing a balanced photograph. The power settings I use most often with this strobe are low and medium. I seldom use high power.

Camera: Nikon F2 in a housing with a dome port. Lens: 16mm full frame fisheye (170 degree picture angle). Film: KR 64. Aperture: f-5.6. Shutter speed: 1/60th. Camera angle: 30 degrees upward. Strobe: one large wide angle strobe set at low power and located 20 inches above the lens.

122

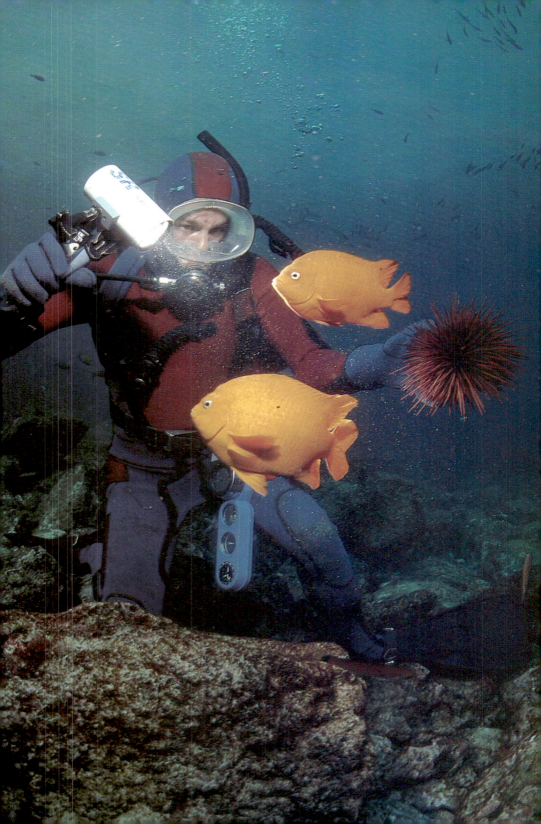

Photo #21 *This is a photograph of my wife, Michele, with an olive sea snake. Although the wisdom of handling an animal whose bite means almost certain death is more than questionable, it yielded an exciting photograph. Michele learned the technique of handling these animals from an experienced teacher, Valerie Taylor. Still, the risk was excessive and I wouldn't encourage her to handle sea snakes again, especially since the photographs were successful the first time.*

The equipment used was a Nikonos and the Nikonos 15mm lens. I took this photograph at a level angle. Ambient light in the shallow waters of the Coral Sea was so high that balancing exposures in wide angle photographs was relatively easy even at level or downward camera angles. In fact, the ambient light almost overpowered the strobe light when set at high power. To help increase the strobe's effectiveness in bringing out colors, I positioned myself with the sun at my back.

Separation often becomes a problem in photographs of divers taken at level or downward angles. Even when the exposures are good, subjects often get lost in rock or coral reef backgrounds. For this reason, I chose to position Michele over sand. Although the photograph might have been acceptable had she been positioned over the coral, the sand produced better separation. I also knew that the coral on either side of the sand would enhance the negative space.

Camera: Nikonos. Lens: 15mm Nikonos. Aperture: f-8. Film: KR 64. Shutter speed: 1/60th. Subject distance: 4½ feet from Michele. Camera angle: level. Strobe: one wide angle strobe at high power.

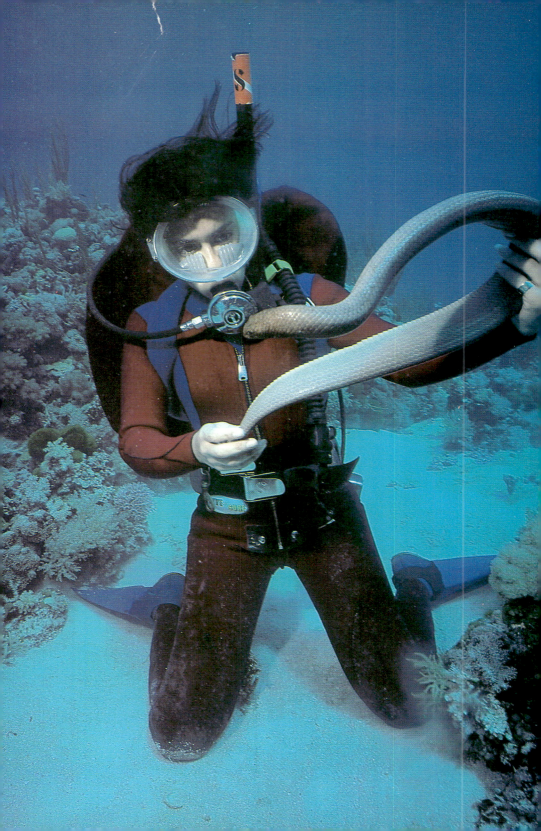

Photo #22 *This is another photograph of Michele, taken in the Coral Sea. Here she is engaged in a more normal underwater activity—taking extension tube photographs. In this case, she is not really taking pictures; she is posing for me while I did the photographing.*

The primary subject in this photo is Michele. However, it is the giant gorgonian coral that makes this photograph a winner. Without the gorgonian, the photograph would lose 99.9 percent of its impact. The gorgonian is negative space.

Obviously, the gorgonian is not in the background by accident. Michele and I swam around looking for good negative space in which to position her. When I spotted the gorgonian I immediately recognized the potential for this photograph. I could have photographed the gorgonian by itself, but I knew that the photograph would need a central point of interest. And, without the diver in the frame, there would have been no size perspective.

To better simulate the act of taking pictures, Michele had her slave strobe turned on. When you use a slave strobe in this fashion (or as in Photograph #20), make certain that the strobe is not pointed at the lens. If it is pointed at the lens, it will produce a nasty flare.

The importance of using a wide angle strobe is exemplified by this photograph. You can see that the 100 degree beam of the strobe did an excellent job of covering the 94 degree lens angle of the 15mm lens. A small macro strobe would have produced a spot light effect, which would have made the use of artificial light too obvious.

Camera: Nikonos. Lens: Nikonos 15mm. Film: KR 64. Aperture: f-5.6. Shutter speed: 1/60th. Camera angle: 30 degrees upward. Subject distance: 7 feet from Michele. Strobe: one wide angle strobe set at medium power and hand-held 2½ feet above the lens.

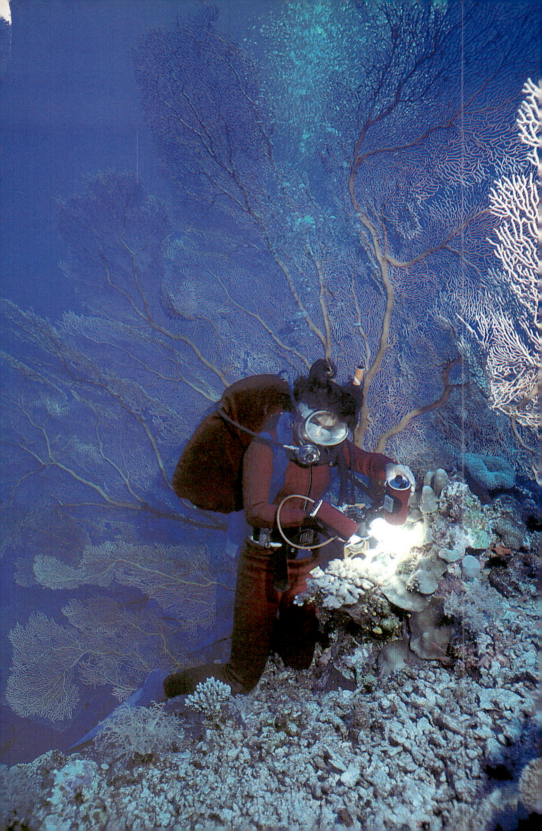

Close Focus Wide Angle Photos

Close focus wide angle

(CFWA) photographs are perhaps the most beautiful type of photograph that can be taken underwater. The result is the beautifully rich colors of a macro shot, combined with the expansiveness of wide angle available light and silhouette photography. The first CFWA photographs I saw were taken by the well known underwater photographer, Jerry Greenberg. At first, I thought this technique was magic, and it took me a long time to figure out just how it was done.

Much of the secret is given away by the name I have arbitrarily given to this kind of photograph. The idea is to take advantage of the extreme depth of field which wide angle lenses are capable of. For example, the 15mm Nikonos lens has a depth of field of from one foot to nearly infinity, when set at f-16. It is therefore possible to get an average sized starfish nicely framed in the foreground with a diver swimming through a kelp forest in the background, all in focus at the same time. The trick is to balance exposures.

BALANCING

Since you will often be using small apertures such as f-16 and f-11, you will balance exposures by photographing the subject (in the foreground) with a strobe held as close as possible and at high power, just as you would with an extension tube photograph. In order for the background to balance you will simply aim straight up, or close to it. Since the lens is so wide, the sun can be in the top of the frame and your subject in the bottom. CFWA photos are usually taken vertically. The result is a colorful subject with spectacular negative space.

130

EQUIPMENT

You will need a wide angle lens and preferably a wide angle strobe. A small strobe might work, but most of the subjects you will choose may not be adequately covered by a small strobe held at such close range.

The lens you choose must be capable of very close focus. The Nikonos 15mm lens focuses closer than one foot. The Seacor 21mm lens, however, only focuses to $2\frac{1}{2}$ feet—not close enough to take good CFWA photographs. The Nikonos 28mm and 35mm lenses are also incapable of focusing close enough, and are not wide enough to do a good job. You must have a very wide angle lens that focuses to nearly one foot.

Since the focusing characteristics of a wide angle lens in an underwater camera housing are influenced by the dome port (see Chapter 1 - REFRACTION), you may need to supplement your lens with a close-up or diopter lens. For example, the Nikon 35mm lens in a housing will only focus from $2\frac{1}{2}$ feet to infinity. With a +2 diopter lens added to the front of the lens, however, it will focus from 1 foot to infinity.

PERSPECTIVE

Perspectives in underwater photographs, and especially in CFWA photographs, are often deceiving. It is not normal for us, as land dwellers, to go around looking straight up. As a result, we tend to view photos which were taken at strange angles as if they were more or less level.

When you look at the examples in this chapter, you may have some difficulty believing that they were shot at extreme upward angles, most of them almost straight up. But if you look closely, there are some clues. In two of the shots you can actually see the sun, and to get the sun in the frame, you have to point the lens at an extreme upward angle, if not straight up. Depth of field and bright backgrounds also indicate that this technique was used. CFWA photographs can also be taken at less extreme angles or even level, but some depth of field must be sacrificed due to the wider apertures necessary.

NEGATIVE SPACE

The CFWA photograph is a combination of brilliant subject and magnificent negative space. The subject will be the primary point of interest in the photograph, but it's a good idea to have a secondary point of interest in the background. Divers, boats, schools of fish, sea lions, or sperm whales are all good subjects for silhouettes in the background. However, divers are the easiest to properly frame since, with a little cooperation, you can direct them to swim into the picture.

If you plan to use a diver as your model, ask him to swim naturally through the frame about 20 to 40 feet away. Some models have a tendency to stretch their arms and legs out in a spread eagle fashion. Others may go where you direct, but then they stop and hang there with their fins sticking out in a Charlie Chaplin stance. Poses like these are unnatural and often look silly in the photograph. Ask your model to repeatedly swim through the frame at a slow pace. It's also best if the model continues to kick, since the moment he stops his fins will begin to do awkward things.

SUMMARY OF PROCEDURES

First, make sure that the lens you are using has a picture angle of 80 degrees or better, and that is is capable of focusing to nearly one foot.

Once underwater, look for subjects that are positioned so that you can get well below them to aim at extreme upward angles. Vertical dropoffs are excellent places to find such material. The subject should be about one foot or larger in diameter. Even at a focusing distance of one foot, a subject that is a foot in diameter would occupy less than half the frame of a lens with an 85 degree picture angle. Smaller subjects would simply be too small to carry any impact.

Since the subject will be a foot or larger in diameter and the strobe will be held very close, the strobe should have a wide enough beam angle to cover the subject at that range. This is why wide angle strobes are recommended for this type of photograph.

If you are using a Nikonos and the subject distance is one foot, set the lens focus so that the depth of field indicators just include one foot. If the lens doesn't have depth of field indicators, or is part of a reflex system, then simply set the focus at the subject distance (one foot).

Next, take a light meter reading on the water directly behind the subject. If you are shooting into the sun and the surface is visible, your reading should be very high and you would bracket your exposures around f-11.

If the surface is not visible, then your reading may be less and you will have to settle for poorer depth of field. Even if you have to shoot at f-5.6, however, the results can be effective. Normally, you should be bracketing around f-11, especially if the surface and sun are visible in the frame.

The important exposure is the one on the subject. Even if the negative space is a stop over or under exposed, it may still be an effective photograph, as long as the subject is properly exposed. In the examples accompanying this chapter, the background might still have been effective with as much as two stops difference in exposure.

After taking your light meter reading on the water behind the subject, set the lens to the proper aperture setting and move in on the subject. Position the subject at the bottom of the frame (if you are shooting a vertical photograph) and then inspect the background for negative space. Hold the strobe close enough to obtain the proper exposure, and take the photograph. Bracket your exposures to properly expose the subject. Don't worry too much about the background exposure, since you can afford considerable latitude there.

Photo #23 *This photograph of a feather sea star was taken at a depth of 110 feet in the Coral Sea. Water visibility was exceptional, allowing our 85 foot dive boat to act as a secondary point of interest in the negative space. The position of the boat makes the extreme upward camera angle a little more obvious than if the boat had not been there. This photograph was taken by aiming the camera almost straight up.*

The subject, a feather sea star or chrinoid, is about one foot in diameter. I used a 15mm Nikonos lens set at one foot and f-16. Then I used my wide angle strobe set at full power and I hand-held it as close as I could to the starfish.

The real trick in CFWA photographs is to balance the exposures, and maximize depth of field. The best camera angle which accomplishes this is nearly straight up.

The exposure on the ocean surface during daytime and with average visibility is going to be f-11, f-16, or f-22. After selecting one of these exposures, the strobe must then be held close enough to the subject to give it the same exposure. Remember that the exposure on the subject is critical. If the background is over or underexposed somewhat, it will have little influence on the acceptability of the results.

In this area of the Coral Sea chrinoids are very abundant. Therefore, I didn't merely photograph this one with the boat "accidentally" in the background. Instead, I specifically searched for an appealing chrinoid to photograph against the negative space of the distant boat. As with macro photographs, to take a good Close Focus Wide Angle photograph, you will often spend your time looking for good negative space, and then search for subjects to photograph within it.

Camera: Nikonos. Lens: Nikonos 15mm. Film: KR 64. Subject distance: one foot. Camera angle: straight up. Aperture: f-16. Shutter speed: 1/60th. Strobe: one wide angle strobe hand-held at one foot from the subject.

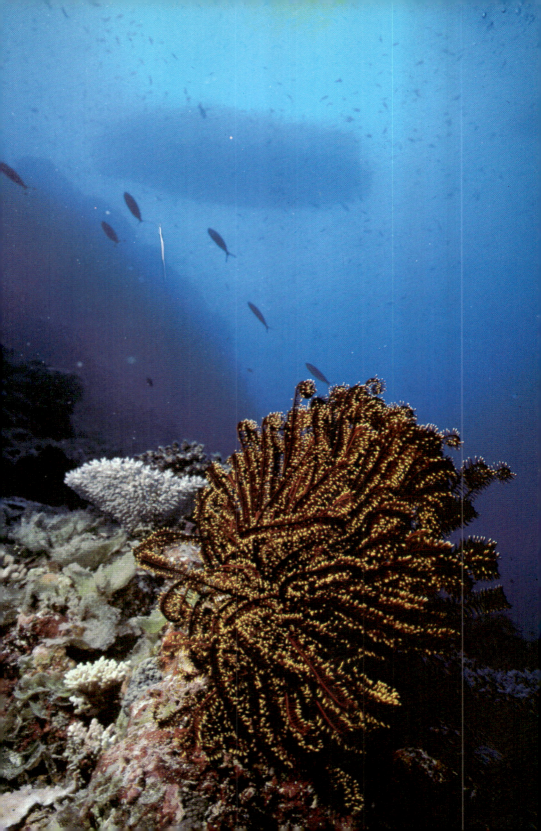

Photo #24 *This photograph of a Garibaldi fish was taken with a 15mm lens set at two feet. The subject is almost too small in the frame to catch the viewer's attention, but the animal's bright color and the separation in the photograph makes it appealing.*

This photograph illustrates why this technique only works on subjects at very close range. Had the subject been any further away from the lens, it would have appeared as little more than an orange speck.

Perspective in this photograph is deceiving (as it is in many CFWA photographs). The photo seems to have been taken at a relatively level angle. If this is the way the photograph appears to you, then take a second look at the water surface. The only way the surface and sun could appear as they do in this photograph, is if the camera were aimed at an extreme upward angle. In this case, the camera angle was about 45 degrees upward.

My exposure setting was f-8. This was determined by my strobe-to-subject distance and the strobe's guide number for that distance. This exposure worked well on the fish, but it nearly over exposed the background.

The subject exposure is of primary importance in CFWA photographs while the negative space can afford considerable latitude. The background in this photograph would probably have been equally effective if exposed as much as two stops darker.

Camera: Nikonos. Lens: 15mm Nikonos. Film: KR 64. Aperture: f-8. Shutter speed. 1/60th. Focus distance: 2 feet on the fish. Camera angle: 45 degrees up. Strobe: one wide angle strobe at high power. The diver was about 30 feet away.

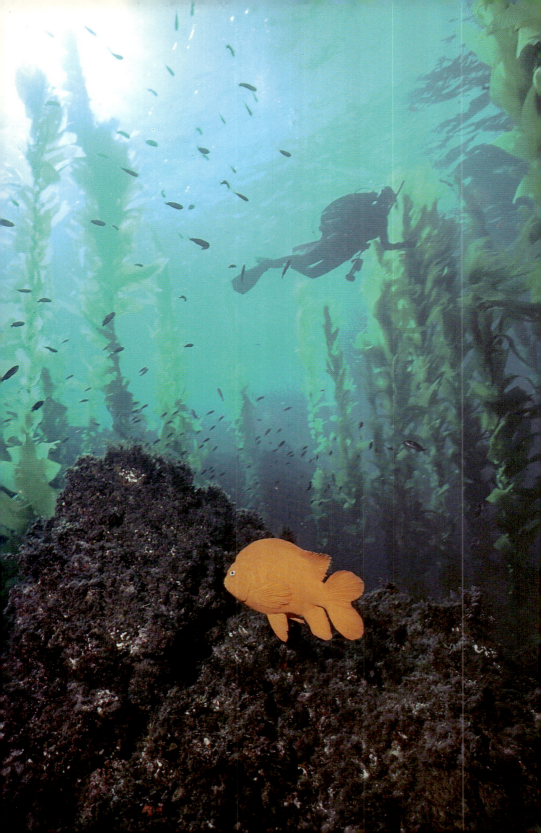

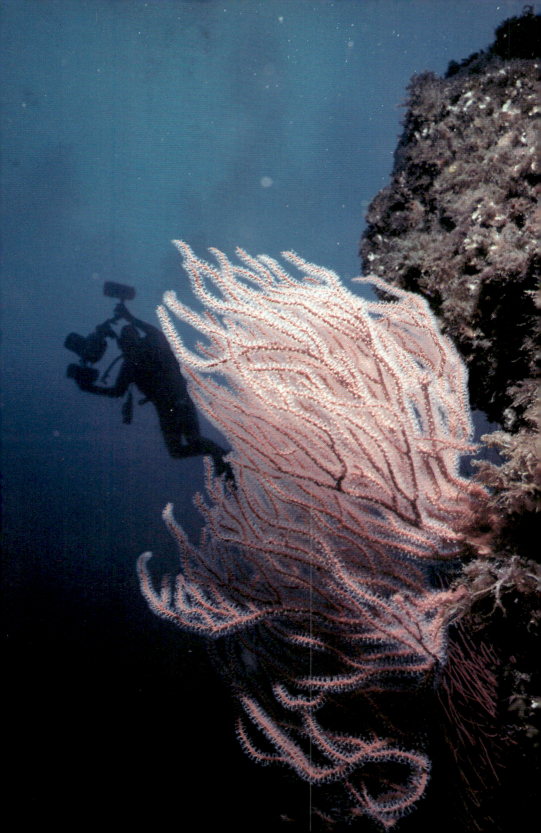

Photo #25 *This photograph of a gorgonian coral was taken at a depth of 120 feet in California water. I used a 24mm lens on a Nikon camera in an underwater housing with a diopter lens in front of the 24mm lens. The subject was about a foot in diameter and was photographed from about one foot away. The diver in the background was about 30 feet away.*

The camera angle was almost straight up. The sun, though not visible from this depth, was located just above the top of the gorgonian coral. Even from this depth, the extreme lens angle gave me an exposure of f-16.

My wide angle strobe was set on high power and was positioned on a ball joint arm to within a foot of the gorgonian, just above the lens (causing some back scatter at the top of the frame). This power setting and strobe-to-subject distance gave me the proper exposure on the gorgonian coral at f-16.

The background, however, is underexposed. But this underexposure does not detract from the photograph's effectiveness. Had the background exposure been increased by as much as two stops, the photograph would probably still be acceptable.

The diver is slightly out of focus in this photograph. But since he is not the primary point of interest, or even part of the actual subject, the softness is unimportant. The diver is part of the negative space. Even with the extreme depth of field of wide angle lenses at this aperture, the background will often be slightly soft in some CFWA photographs. However, since the background is negative space and not subject, the softness is acceptable.

Camera: Nikon F2 in a housing with a dome port. Lens: 24mm with a +2 diopter lens. Film: KR 64. Shutter speed: 1/60th. Subject distance: 1 foot. Aperture: f-16. Camera angle: nearly straight up. Strobe: one wide angle strobe at high power and one foot away from the subject.

Nikonos 35mm and 28mm Lenses

The Nikonos

35mm and 28mm lenses are the most commonly used lenses underwater. The 35mm lens comes standard with new Nikonos cameras. The 28mm lens is relatively inexpensive and is a logical second purchase. Most professional underwater photographers use these lenses to a rather limited degree (excluding the use of the 35mm with extension tubes). This doesn't mean that these lenses are not capable of taking good underwater photographs. It simply means that the use of these two lenses is limited. If you work within these limitations, however, you can get beautiful professional quality photographs.

THE 35mm LENS

Since the Nikonos 35mm lens comes standard with the Nikonos camera, it is used more than any other lens underwater. The designers of the camera system wanted to offer a lens that was capable of taking both above water and underwater photographs. This they certainly accomplished. However, in doing so they produced a lens with very limited capability underwater.

SCATTER AND COLOR ABSORPTION

There are two major factors which influence the limitations of the 35mm lens. They are scatter and color absorption.

Remember that even in clear tropical water, images are scattered as they pass through the water. In 200 foot visibility, subjects ten feet or more from the lens are significantly scattered. When photographing subjects at these distances you must settle

for progressively greater image degradation. When using super wide angle lenses such as the Nikonos 15mm lens, subjects the size of divers appear so small in photographs taken at ranges of ten feet or more that they can be only secondary points of interest. When using this lens, you must get very close to properly fill the frame with a diver. This greatly minimizes scatter.

With the 35mm lens you must be nearly ten feet away from a diver to get his entire body in the frame! So unless you move in close and photograph only the diver's head and shoulders, you must settle for a scattered image.

This doesn't mean that the slightly scattered image of a diver, taken at ten feet with a 35mm lens, is a totally useless photograph. It means that if you photograph divers with a 35mm lens, and your buddy uses a 15mm lens to do the same thing, your photographs will be of inferior quality (assuming your buddy knows which end of the lens to point at the diver). Publishers certainly recognize this quality difference.

The same problem occurs in regard to color absorption. With a super wide lens you can get close enough to divers to capture good colors with your strobe. With a 35mm lens you must back off so far, to photograph a diver, that little color from the strobe makes it back to the lens. So not only are your diver photographs more scattered than your buddy's, but the colors are not nearly as good.

So what do you do? Take your 35mm lens and chuck it out beyond the surfline? Well, not yet.

If you stick to photographing subjects at close range, you can minimize scatter and color absorption. Of course, you won't be taking photographs of entire divers, but you should be able to find many other more suitable subjects.

The Nikonos 35mm lens is most effectively used at ranges from minimum focus (2.75 feet) to six feet. The image quality of photographs taken at minimum focus is excellent and certainly publishable. At three feet you can get sharp subjects and good colors. At six feet colors and sharpness are acceptable. Beyond six feet, however, the image really begins to fall apart.

Unfortunately, using the Nikonos 35mm lens at near minimum focus is not an easy task. There are major problems that you will encounter with this lens at close range. One is the lens' very limited depth of field. Although the lens is a 35mm, it functions more like a 50mm lens underwater due to refraction through the lens' flat port. In fact, using the 35mm underwater is not unlike using the 55mm Micro Nikor lens underwater through a dome port. Image size and depth of field at 3 feet are quite similar. The problem is that the Nikonos system has no "through the lens" focusing capabilities. And, as with the 55mm lens, focus with the Nikonos 35mm lens is critical. At minimum focus and f-5.6, depth of field is a matter of inches.

Again, I'm not trying to convince you to chuck your 35mm out into the surfline. Photographs taken with this lens at near minimum focus with strobe fill can be of truly excellent quality. However, your results will include a high degree of off focus slides even if you become quite skilled with the lens. But with practice, you should still be able to take many very good photographs.

The second problem with the 35mm is in framing. Again, because the lens is so narrow and because you can't view the subject through the lens, your results will probably reflect a large percentage of mis-framed photographs. However, with practice and with a supplementary viewfinder properly adjusted for parallax, you can go a long way toward overcoming this problem.

SUBJECT SIZE

Before you set out to photograph sea urchins and nudibranchs at minimum focus with your 35mm lens, you should realize what the frame size is at 2.75 feet.

The frame size of the 35mm is relatively wide at minimum focus. Even at three feet you will be getting a frame size that is nearly two feet across! Unfortunately, this is too small to fit a whole diver into, and too big to fit most common fish. So what does that leave?

Use your imagination. A Nikonos 35mm lens at minimum focus can nicely frame the head and shoulders of a diver. It can also capture beautiful seascapes of fish, or other marine life, against well composed negative space.

Another excellent use of the Nikonos 35mm lens is to capture marine life that is difficult to approach. Consider, for a moment, a six foot shark. If you photograph this animal with a 15mm lens, you must be within three feet of it for the shark to appear reasonably sized in the frame! Perhaps you can't get that close (or don't want to). With the 35mm lens you can frame the subject nicely from six feet away.

THE NIKONOS 28mm LENS

The 28mm lens is considerably more versatile than the 35mm. Everything that the 35mm can do, the 28mm can do more effectively and with better quality. Most importantly, the depth of field at near minimum focus with the 28mm lens is much greater than that of the 35mm and thus allows a much higher percentage properly focused results. However, the 28mm lens suffers from many of the same limitations as the 35mm, only to a much lesser degree.

With the 28mm lens you can take diver photographs which are vastly superior to those taken with the 35mm, but they still won't compete with the super wide lens that your buddy is using. You can also get considerably closer to small subjects since the 28mm focuses down to a minimum focus of two feet instead of 2.75 feet. But the wideness of the lens still makes framing fish and other common marine animals difficult.

Whereas the 35mm lens is almost never used by professional underwater photographers (without extension tubes), the 28mm lens has a variety of important uses that make it a standard tool of most pros.

Photo #26 *This is my first shark photograph. It was taken in open water off San Diego from a shark cage with a Nikonos camera and the Nikonos 35mm lens. Although I seldom use the Nikonos 35mm in this application today, it took me many years to improve on this photograph.*

The Nikonos 35mm lens is a useful tool for photographing relatively large animals which are difficult to approach. This photograph was taken from a distance of six feet. At the time I knew little about blue sharks and this was about as close as I wanted to get.

In many cases, sharks and other large marine animals will simply not permit a diver to approach close enough to use a wide angle lens. In these instances, the 35mm lens may produce a suitable photograph where a wider lens prevents acceptable framing. Certainly, a 28mm lens or a 15mm lens will produce better color and increased sharpness by minimizing the water between the lens and subject, assuming the photographer can get close enough. But if you can't get close, making the use of a wide angle lens impossible, a 35mm lens may produce an acceptable photograph where the alternative is no photograph at all.

Due to the narrow picture angle of the 35mm lens underwater, framing can be a major problem. The viewfinder which is built into the Nikonos I, II, and III are all but useless underwater. The finder in the Nikonos IV is only slightly better. Attempting to frame a moving target such as this blue shark without a viewfinder will produce numerous photos of just the animal's fin or tail or of entirely empty blue water. The solution to this problem is a supplementary viewfinder which mounts on top of the camera. Several underwater photography equipment manufacturers make these finders.

Color absorption was minimized in this photograph by the extremely shallow depth at which it was taken (about two feet).

146

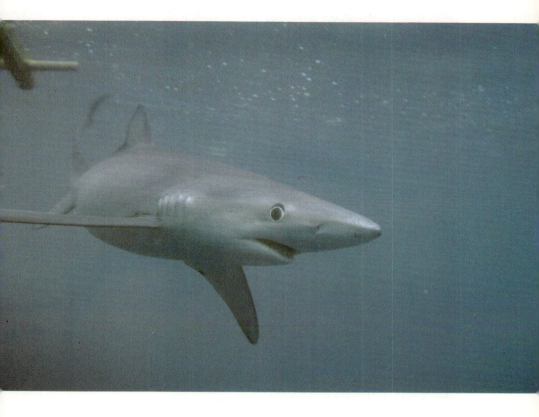

Camera: Nikonos II. Lens: Nikonos 35mm. Film: Ektachrome 64. Aperture: f-8. Shutter speed: 1/60th. Camera angle: 20 degrees upward. Subject distance: six feet. Strobe: none.

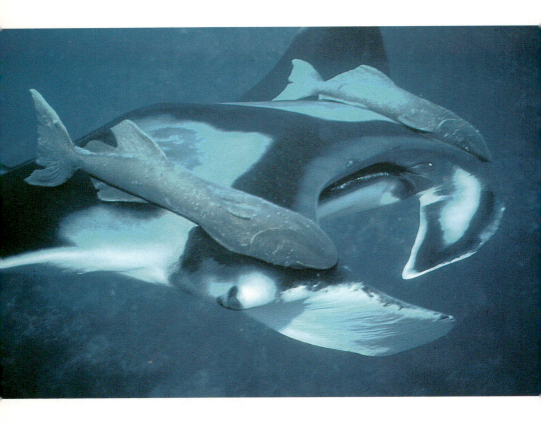

Camera: Nikonos III. Lens: 28mm Nikonos. Film: KR 64.
Aperture: f-8. Shutter speed: 1/60th. Camera angle: Slightly down.
Subject distance: 3 to 4 feet. Strobe: one wide angle strobe hand held
above lens at medium power.

Photo #27 *This photograph of a manta ray with two hitchhiking remoras was taken by Marty Snyderman. Normally, Marty would have used his 15mm Nikonos lens to photograph a manta ray. But, in this case, he wanted a clear shot of the remoras on the manta instead of just the manta itself.*

Using the 15mm lens, Marty would have had to be within 18 inches of the two foot long remoras for their image to occupy half the length of the frame. The use of the super wide lens at such close range would have necessitated considerable cooperation from the ray and would have created a rather distorted image. Instead, Marty used the Nikonos 28mm lens which allowed him to back off to almost four feet, resulting in a less distorted image and considerably more room to maneuver.

This is one of many cases where the Nikonos 28mm lens is ideal. The subject (the remora) is too large for a reflex macro system and is moving much too fast to allow focusing and framing with a macro lens. Yet, the subject is too small and difficult to approach for photographing properly with a super wide lens.

The Nikonos 28mm lens fits nicely in between the two extremes. It's wide enough to capture and properly frame the remora as well as the face of the manta the remora is riding on. It allows you to get close enough to add good fill lighting, but doesn't necessitate your being so close that the animal is going to eat you or run over you immediately after pressing the shutter release. It allows you to take good photographs of relatively large animals from a practical distance.

Many other subjects lend themselves well to the 28mm lens. Large fish, sea lions, sharks, and groups of animals are good subjects for this lens.

Photo #28 *I took this photograph to demonstrate the potential of the Nikonos 35mm lens for getting good strobe-produced colors. Certainly it's not easy to get publishable underwater results with this lens (unless, of course, you use an extension tube or other optical accessory). But good results are possible.*

The 35mm lens has severe limitations underwater because it has a narrow picture angle, poor depth of field, and a minimum focus of only 2.75 feet. At minimum focus it can produce sharp images with good color, but the limited depth of field makes estimating the focusing distance difficult.

This photograph was taken at a focus distance of 3 feet and at an aperture of f-5.6. This combination produced a depth of field from 2.75 feet to 3.5 feet—only about 9 inches. Many of the photographs developed from this roll of film were submitted to the round file because I had failed to estimate my focusing distance perfectly. Had I used a 28mm lens, the substantially increased depth of field would have produced much better results.

If the 35mm lens is the only lens you have, then you must learn to get good results despite the limitations. When shooting at minimum focus, be very careful about estimating your focusing distance. It may even be a good idea to make up some form of measuring device like a pole with focus markings on it.

If color is important to your photograph, limit your focus to between 2.75 feet and 6 feet. Even in clear waters, photographs taken with the 35mm lens at distances over 6 feet will suffer badly from effects of scatter and color absorption.

To frame your subjects you need to use a viewfinder. The viewfinders that are built into the Nikonos I, II, and III cameras are small and all but impossible for a diver to use underwater. The viewfinder on the Nikonos IV is only slightly better. I used an accessory viewfinder that mounted on the top of the camera and was adjusted to compensate for parallax (the difference between what the viewfinder sees and what the lens sees, due to the separation between the two).

Camera: Nikonos III. Lens: Nikonos 35mm. Film: KR 64.
Aperture: f-5.6. Subject distance: 3 feet. Shutter speed: 1/60th.
Camera angle: 20 degrees upward. Strobe: one wide angle strobe
hand held at upper left on medium power.

Photo #29 *This photograph of a moray eel was taken in the Sea of Cortez by Mike Farley. It demonstrates what can be done with the Nikonos 28mm at close range.*

The moray is about four feet long and its head is about 5 inches in diameter. Mike took the photograph at the lens' minimum focusing distance of 2 feet. He illuminated the frame with a single wide angle strobe hand held at the upper left, giving him an exposure of f-8.

Used at minimum focus, the Nikonos 28mm lens can produce excellent portraits of a wide variety of marine animals. The frame size at this range is just about 2 feet across. This doesn't allow you to take full frame photographs of the animal's face (unless it's a rather large critter) as you would with a macro system, but it does allow composition of an animal's face within interesting negative space.

Certainly, the key to using this lens for taking portraits is negative space. With a macro lens, you can compose portraits of faces which all but exclude negative space. But due to the frame size of the 28mm lens at minimum focus, you will nearly always have plenty of negative space in your portraits. The trick is to use this negative space to your advantage. Instead of taking photographs where the animal is small within a frame which is overwhelmed by distracting negative space, you must create images with good negative space and a subject within it to provide a center of interest.

There are two approaches to taking photographs where negative space is of major importance. One is to find a subject you wish to photograph and then compose the subject within the existing negative space as well as possible. This is what Mike has done with this moray. The other approach is to look for an area of outstanding negative space and then discover subjects within it. If the subjects you are photographing are relatively common, this second approach is the best way to get photographs that will stand out among all other photographs of that subject taken by other photographers.

Camera: Nikonos II. Lens: Nikonos 28mm. Film: KR 64.
Aperture: f-8. Shutter speed: 1/60th. Camera angle: Slightly down.
Subject distance: 2 feet. Strobe: one wide angle strobe hand held at
upper left.

Selling Underwater Photographs

There are numerous reasons

for taking up underwater photography. Probably the most important one is that it enhances your enjoyment of diving. Certainly this was my primary reason. After you have been diving a year or so, and have seen many of the more common underwater sights, you will probably need to take up some kind of specific underwater activity to maintain your interest.

You might take up spearfishing, shell collecting, fish watching, wreck diving, or any number of underwater hobbies. Without one of these activities, you may find it increasingly difficult to justify putting on the heavy gear and getting wet, cold, and uncomfortable. Underwater photography is a good hobby to turn to. The more you enjoy underwater photography the more you will enjoy diving.

In order to enhance your enjoyment of underwater photography, however, you will need to do something with the pictures you take besides look at them once and then put them in a box. There are a variety of things you can do.

You can make prints of your photographs to decorate the walls of your home. Then you can continually upgrade your wall decor as you improve your photography.

You can develop slide shows to entertain and educate your friends or club members. Remember that the majority of people on this planet will never see the environment below the surface of the sea. Your photography can have important value if you use it to educate these people, creating an appreciation of this environment in their minds.

You can make a collection of your photographs. Instead of fish watching (collecting names of various fish in a notebook) you

can collect photographs of various species of fish in your area, always trying to expand the number of species you have in your library.

You can also sell your photographs. It is even possible to make a living as an underwater photographer. However, breaking into the publishing market can be hard and frustrating work. It can be accomplished only if you place greater importance on enhancing your enjoyment of diving and photography rather than on getting rich.

I began taking underwater photographs in 1972. Within a few months of getting my first exposures I became determined to make my living at it. But it wasn't until six years later that I was able to make underwater photography my full time work. During those six years, I averaged more than 150 dives per year. They were six wonderful years with hundreds of memorable dives.

Whether or not you attempt to make it your profession, you can make money selling underwater photographs. And even if the money you make doesn't entirely pay for your film and processing expenses, the satisfaction of seeing your photographs published may be adequate compensation. No matter what sparks your desire to see your photographs published, there are several things you should know about selling photographs if you are going to give it a try. There are three primary reasons why publishers buy photographs.

SPECTACULAR PHOTOGRAPHS

One of the reasons why publishers buy photographs is that the photographs submitted are absolutely spectacular. You won't go out and take this kind of photograph every day or even every year. If you spend hundreds of hours in the water, you may occasionally get "lucky". Remember, however, that luck is a combination of opportunity and preparedness. If you don't spend those hundreds of hours in the water then you aren't likely to have the opportunity. And if you don't take your camera with you on every dive (and know how to use it) then you won't be prepared when the opportunity comes along.

There are a wide variety of underwater subjects that make spectacular photographs. Generally, large marine animals are the subject of the most common ones. Since whales are about as large as marine animals get, they are very marketable subjects. However, you'll be much more successful if you photograph a species that hasn't already been excessively photographed.

Even if you take good pictures of humpback whales, you may have a hard time selling them since they have already been widely photographed and published. If a publisher needs a humpback whale photograph, he will just request it from an already established photographer. On the other hand, if you have a good underwater photograph of a blue whale, you might make thousands of dollars and become famous overnight.

Photographing a giant marine creature may be a tough approach. Instead you might concentrate on animal behavior. If you can take clear photographs of animals engaged in behaviors that have not been widely photographed before, you will have something of value. Certainly, it would be most advantageous to get large animals engaged in behavior. A photograph of a sperm whale eating a giant squid would be nice. But even small animals engaged in unusual behavior will sell.

One such example in this chapter is a photograph of two starfish spawning. I took the photograph during a beach dive off the coast of San Diego, California. Although this species of starfish has been photographed thousands of times before, this photograph has been sold many times because photographs of this behavior are unique.

Another kind of spectacular photograph is one showing a diver interacting with a marine animal. The photograph of the diver riding the manta is a good example. Mantas have been photographed before, but the diver riding on its back adds a whole new dimension. People (and publishers) identify with the diver and therefore interest in the subject soars.

Of course, you might photograph divers feeding fish. But since this kind of photograph is relatively common, your pictures will not carry the impact of being unique. If you photograph a diver feeding garden eels, however, you could probably sell the pictures right away since it hasn't been done before.

SPECIFIC PUBLISHER NEEDS

Your chance to photograph something spectacular will come if you dive long enough. Don't expect it to happen next week, but certainly be prepared if it does. In the meantime, the second reason publishers buy photographs is that they have a specific need for them at the time.

If a publisher is doing a story about starfish and you just happen to submit good starfish photographs that day, you will probably sell some. It's the timing that's important. If the publisher needed the starfish photographs last week or he doesn't need them until next year, he will probably send them back.

You probably won't like it when your photographs are returned with a short rejection slip, but it's something you must get used to. Even well known photographers see many more rejection slips than letters of acceptance. If you can't take rejection with a smile on your face, you're headed for the wrong business.

Of course, it helps to know what a publisher will need ahead of time. Often this is something you can find out simply by inquiring. Many magazines won't take the time to tell you what they are planning in the future, but some will. If a magazine lets you know that they are planning a story on squid next year, you will be in a better position to sell your photographs (assuming, of course, that you have photographs of squid). This is where a well developed, carefully organized photographic library comes in handy.

If you have been taking underwater photographs for only one or two years, then you usually won't have the specific photographs that the publisher requests. It takes a long time to develop a comprehensive library of underwater photographs. However, developing such a library is 90% of the fun in underwater photography. The more you dive with your camera, the larger your library will grow. Eventually you will begin having the material that the publishers are looking for.

This doesn't mean that you must wait several years before you have any chance of publishing your first photograph. There is something you can do while developing a library, which brings

us to the third reason that publishers buy photographic material. You can create photo stories.

WRITING

If you write an article based on an interesting series of photographs you have taken, you have a much better chance of selling the material than if you submit the photographs alone. This saves the publisher enormous amounts of time and trouble by not having to request photographs for manuscripts submitted without them. Therefore your manuscript is considerably more appealing than one submitted by a writer who has not supplied photographs.

The photographs you submit with the article must, however, represent complete photographic coverage. Your photographs must tell a story which supports the manuscript. This is called a photo story.

If you write a story about moray eels, then your photos should show as many aspects of moray life as possible. You should show morays feeding, morays mating, baby morays, morays defending territories against natural enemies, and as many other aspects of moray life as you can capture on film. Although you should certainly include a good moray portrait, it probably won't be enough by itself to make your story sell. You must approach moray eels as a photo-journalist and not as just a hobby photographer.

Shooting a comprehensive photo-story will certainly take time; probably more than one dive, and perhaps dozens of dives. But the result is far more valuable and marketable than a box of unrelated photographic material. Shooting underwater photo-stories is also totally absorbing and bunches of fun.

But what if you can't write? Concentrate on shooting photo stories anyway. If you have completed a photo story, you should have little difficulty finding a good writer to collaborate with. Writers who are non-photographers have the same problems as photographers who are non-writers.

If you can't find a writer to work with, then submit the photo story to a publisher by itself. If it is any good, a publisher can always find a writer to prepare the manuscript. Certainly you will have a much easier time selling a photo story than selling a bunch of unrelated "pretty pictures".

What publishers should you submit to? Go to the magazine rack and look for magazines that have articles about wildlife or science. Keep in mind that magazines which regularly publish underwater articles probably have established underwater contributors. Look for suitable publications which don't carry large amounts of underwater material.

What about diving magazines? Understand that major diving magazines may receive over 100 manuscripts per month. If your story can compete then go ahead, but your prospects will be better elsewhere.

As you compile your photo stories, your library will grow. Eventually you will begin to have the photographs that publishers request. And as you spend hundreds of hours underwater developing this library, sooner or later you will stumble across that opportunity to take a really spectacular photograph that sells all by itself. It simply takes lots of time and dedication.

ROUND FILE

One of your most valuable tools in improving your photographic library is your round file. If the photographs you take are not of publishable quality, then throw them away. Unpublishable photographs clutter your library. If you send this kind of material to publishers you can damage your blossoming reputation. When you sort through your recently developed photographs, make certain that you would be proud to see them in print before you decide to keep them. If they don't measure up to the state of the art, then chuck 'em in the round file.

A Photo Story

The following photographs comprise a photo story about squid as it might appear in a magazine.

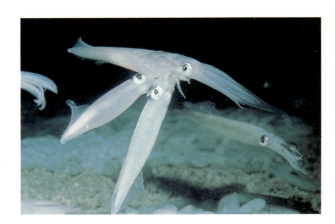

1. Three squid involved in a frenzied mating behavior.

2. A female squid plants her egg casing in the sand among countless others.

3. An angel shark feeding on a squid.

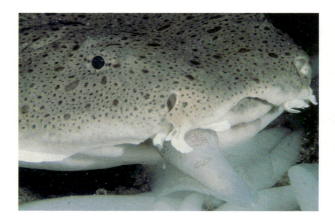

4. Each egg case holds over one hundred baby squid.

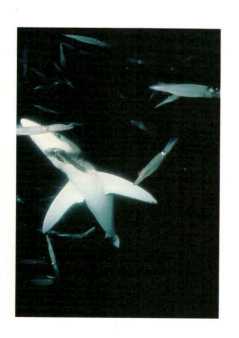

5. Dr. William Long discovers an angel shark among the squid eggs.

6. A blue shark eats its way through the giant schools of mating squid.

Photo #30 *This photograph of a California gray whale was taken with a Nikonos camera, 21mm lens, and a large, wide angle strobe. Although this was a small animal (as whales go) of only about 25 feet, it was still a very large object to photograph underwater.*

In addition to the usual difficulties of photographing large animals underwater, visibility in the kelp bed near San Diego was only about 20 feet. This eliminated the possibility of getting a photograph of the entire animal, so I concentrated on capturing portraits of the animal's face.

There are two reasons that make this photograph easily marketable. First, the subject is a very large marine animal. The larger the animal is, the more interest viewers seem to show in the photograph. The second reason is that underwater photographs of this animal are extremely rare. The combination of these two factors has allowed me to sell this photograph (and other photos taken at the same time) over and over again.

When photographing a large, fast moving subject like this whale, you don't have time to creafully select your camera angle and position your strobes as if photographing a reef fish. It's best to have a few general ideas in mind and then quickly shoot as much film as you can before your opportunity evaporates. In this case, after attempting to photograph gray whales for months, I was able to make four dives with a relatively cooperative animal. I shot four rolls of film, concentrating on portraits of the whale's face. Of these, about a half dozen photographs turned out to be publishable.

The 21mm wide angle lens was used to capture as much of the animal in the frame as possible, at a minimum distance. The strobe was used to fill in color and definition to the face. Without the strobe, the photo would have been an unrecognizable silhouette.

Camera: Nikonos II. Lens: Seacor 21mm. Film: High speed Ektachrome ASA 160 (due to very low light levels in the kelp bed in late afternoon). Subject distance: 4 feet. Shutter speed: 1/60th. Aperture: f-5.6. Strobe: one wide angle strobe at upper right set at low power.

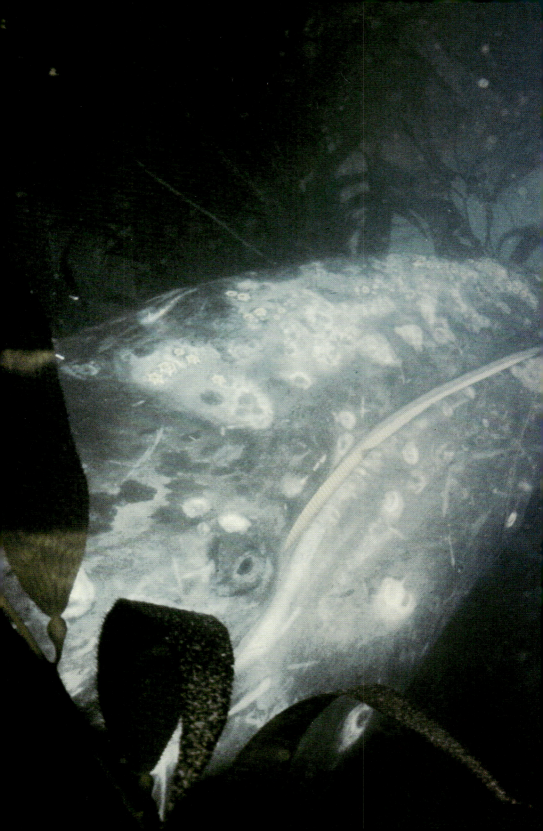

Photo #31 *Unlike the other photographs in this section, the subject here is neither large nor threatening. However, I have repeatedly sold this photograph year after year. The reason is behavior. This photo shows natural wildlife behavior, and behavior sells.*

You may have the most beautiful photograph of a starfish that a publisher has ever seen, but a good photo showing starfish behavior will be worth ten of the pretty shots. Photographs demonstrating animal behavior give the publishers something to write about in the text or captions, and they provide interest for the readers. Behavioral photographs have something to say.

This photo of two blood sea stars was taken near San Diego, in the area's most commonly dived spot: La Jolla cove. The starfish are engaged in what is probably spawning behavior, although some authorities suggest that they may be filter feeding instead.

The photograph was taken with a housed Nikon camera and 55mm macro lens. I used two small strobes to evenly light the subjects.

Taking behavioral photographs like this one does not require travel to exotic diving sites or super sophisticated equipment (this one could have been taken with an extension tube). What it does require is enormous amounts of underwater time, and considerable determination.

Purposefully spending hundreds of hours underwater studying wildlife is one of underwater photography's greatest rewards. Hopefully, this will be reward enough, since years may go by before you begin selling your photographs. But if you put in the time, opportunities will occasionally present themselves. These behavioral photographs will sell because they are rare and interesting, whether the subjects are manta rays or blennys.

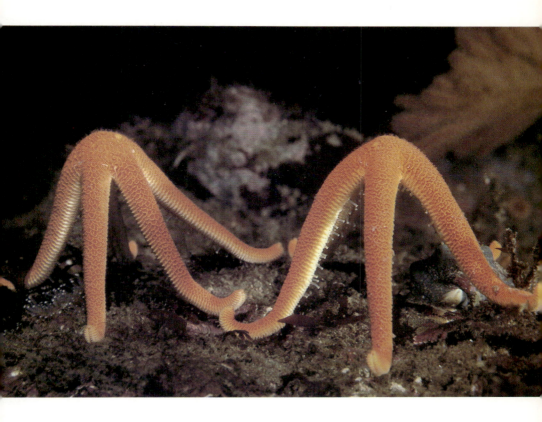

Camera: Nikon F2 in underwater housing with flat port. Lens: 55mm macro. Film: KR 64. Aperture: f-11. Shutter speed: 1/60th. Strobe: Two small strobes set above and at 45 degree angles to either side of subject. Camera angle: slightly up. Subject distance: 1 foot.

Camera: Nikonos III.
Lens: Nikonos 15mm.
Film: KR 64. Aperture:
f-4. Shutter speed:
1/60th. Strobe: wide
angle strobe set at
medium power. Camera
angle: 45 degrees down.
Subject distance: 15 feet.

Photo #32 *This is one of the most valuable photographs I have ever taken. It shows a diver and a manta ray. The manta provides a sensational subject and the diver provides human interest.*

It's the activity in which the diver (Gordy Waterman) is engaged that makes this photograph especially spectacular. Not only is he riding on the manta's back, but he is using large remoras as handle bars! This gives the photograph an enormous human interest value. You can't help but be empathetic with the diver and wonder what such an experience must have been like.

Technically, this photograph is far from perfect. The original is underexposed (resulting in considerable loss of quality when reproduced), and it is not quite sharp. Nevertheless, the subject value is so high that it has sold time and time again—alone, or as a climax to photo stories about mantas or manta riding.

I took the photograph with the Nikonos and 15mm lens. And I used a wide angle strobe to enhance colors and definition. I was able to take only two photos before I ran out of air, and this was the best of the two.

Camera: Nikonos III. Lens: Nikonos 15mm. Aperture: f-8. Film: KR 64. Subject distance: 3 feet. Strobe: wide angle strobe set at medium power held at upper left. Shutter speed: 1/60th. Camera angle: straight up.

Photo #33 *This photograph has two ingredients that make it especially marketable. First, the subject, a blue shark, is a large spectacular marine animal. Second, the shark is engaged in a form of natural behavior: eating squid.*

Certainly, there are lots of photographs showing sharks eating. Due to the sensational nature of feeding sharks, these photos are quite marketable. But generally, photos of feeding sharks are taken in obviously baited and unnatural situations. In this case, however, the shark is engaged in natural predation. A photograph of a large sensational animal engaged in natural behavior is a winning combination.

Although this photograph is easily marketable standing alone, it is considerably more valuable as a climax to a photo story.

After viewing the developed photograph, I realized the potential for a good photo story and returned to the site to expand my coverage. The story is about the squid life cycle. My coverage included mating squid, laying of eggs, baby squid developing inside the egg cases, a squid portrait, additional predation by marine life and man, and divers among the squid.

I had to wait for the following season to complete the photo story. In the meantime, I held on to this blue shark photo and didn't include it in my normal submissions to publishers. I realized that the complete photo story would be more marketable and more rewarding financially than the shark photo alone.

Although a photo story on the squid life cycle is marketable, it's this dramatic photograph of the shark feeding that sells the package to publishers.

The photograph was taken at night during an especially large squid run. I used a 15mm lens on my Nikonos and a large wide angle strobe. The photograph was taken at a straight upward camera angle. The orange glow at the upper left of the frame is light from a squid fishing boat.

Automatic
Exposure
Photography

The latest Nikonos camera

models offer TTL (Through the Lens) automatic strobe exposure operation. This means that, using a strobe which incorporates the proper electronics (including, of course, any of several Nikonos strobe models), the camera's light metering system can tell the strobe to automatically adjust its power to produce the proper exposure on the film. This system works extremely well for some kinds of underwater photographs and only a little less than extremely well for others.

Many professional photographers (and serious amateurs) shy away from automatic camera and strobe operation. There are a couple of reasons for this. One is that these pros have been taking photographs for a long time and have become stubbornly set in their ways. Since automatic systems were not widely available only a few years ago, these photographers have learned to get very good results without them. Why change? All of the photographs in this book, with the exception of those accompanying this chapter, were taken without TTL simply because TTL wasn't available when they were taken. Another excuse is that pros like to have full control over the creative process. They don't want the creative aspects of exposure determined by a silicon chip.

There may be some validity to this latter argument. Proper exposure is not an absolute. A "perfectly" exposed photograph may also look good with a full stop less exposure producing more deeply saturated colors. Or you may want your photograph even a little lighter than normal. The "perfect" exposure may make a better print to hang on your wall, but the under exposure may look much better projected. It is, however, easy (and, in the case of wide angle photographs, advisable) to bracket your TTL exposures.

174

But so much for the rather feeble arguments against TTL automatic strobe exposure. While it may be reasonable to shoot a wide variety of exposures of something above water where you can change film easily, underwater it is probably much smarter to get more subject diversity on your roll of film (happy in the knowledge that your TTL is going to produce consistent results), than it is to spend your dive and film bracketing exposures.

Underwater you should use your 36 exposures as economically as you can. You can't change film underwater (or at least you shouldn't). In some situations (as with extension tube photography), by using TTL you need only bracket for composition and not exposure. If you can properly photograph 10 subjects using a manual system, you may be able to photograph twice as many subjects with a TTL system. The result is more photographs per roll for your library and less for the round file.

As discussed earlier in this text, the Nikonos camera may be used as the central component of two different systems: an extension tube system (extension tubes and close-up lenses) and a wide angle system. TTL is useful in both configurations, but must be used a bit differently with each.

NIKONOS TTL EXTENSION TUBE PHOTOGRAPHY

To say that the Nikonos TTL strobe exposure system works extremely well for extension tube photography is almost an understatement. If the system is set up properly, you can expect every frame on the roll to be exposed perfectly.

The setup is easy. The camera is mounted on a bracket which will also accept a strobe arm. The strobe may then be positioned on the arm to light the subject, or the arm and strobe may be removed for hand held operation.

According to the Nikonos V manual, the shutter speed may be set at any setting EXCEPT M-90 or B. At M-90 and B, the TTL feature will not operate. When the camera is set at A (automatic aperture priority) or speeds of 125 or greater the camera automatically switches to the sync speed of 90th of a second when the strobe is turned on. If the camera is set at 30th or 60th, the camera will operate at those speeds which will work fine with the

TTL. Certainly, there is no reason to use a shutter speed of 30th when taking macro photographs, but if you do accidentally choose this setting, your pictures will come out fine despite yourself. The Nikonos manual suggests setting the shutter speed at A.

Next, you check the ISO rating of the film you plan to use and select this ISO number on the ASA/ISO film speed dial of the camera.

As with manual extension tube photography, the aperture is set at F-22. The TTL is capable of producing good exposures at any aperture. However, F-22 produces maximum depth of field.

Strobe to subject distance still should be minimized with your TTL system. With most strobes set at full power, a good 1:3 extension tube exposure will be produced when the strobe is held about 10 inches away from the subject. If a TTL strobe is positioned further away than this, it may not be capable of producing enough exposure. For example, if the strobe is set 18 inches from the subject, the TTL meter will tell the strobe to use all the power it has and this still won't be enough. So when positioning the strobe for TTL extension tube photographs, position it close to the subject—about six to eight inches away.

Multiple TTL strobes may also be used. However, to utilize the TTL feature, both strobes must be connected to the camera via a "Y" connection. Nikonos makes such a cable allowing two Nikonos strobes to be plugged into the camera and enabling both to operate on TTL.

Using the above setup, you should be extremely happy with the resulting exposures. But if you still want to bracket exposures you can do so by manipulating the ASA/ISO film speed dial. You might consider doing this should you find that "once in a lifetime" subject that justifies shooting an entire roll of film. If you are using ISO 100 film, you should take the majority of your photographs with the film speed dial set on 100. Then if you want to darken some of your exposures, change the setting to 150 to reduce the exposure by 1/2 stop or change the setting to 200 to reduce the exposure by a full stop. Further reduction should almost never be needed. By changing the film speed dial to 75, you can add 1/2 stop of exposure. You may want to take two or three photographs

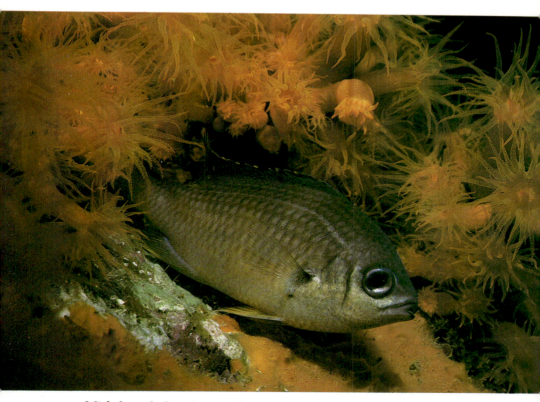

Michele took this photograph with a Nikonos V, a single Nikonos SB-103 TTL strobe, and a 1:3 extension tube.

out of a whole roll with a 1/2 stop over exposure, but more than that should not be necessary. The Nikonos TTL almost never under exposes an extension tube photograph unless the strobe is positioned too far away from the subject.

For the most part, this kind of bracketing should not be necessary. You may, after several rolls of film, decide that you like your photographs exposed a little darker or lighter than the results you have been consistently getting. If so, you can adjust for this exposure change using the ASA/ISO film speed dial. Remember that doubling the ISO number will result in halving the exposure produced by the strobe, and halving the ISO number will result in doubling the exposure produced by the strobe.

NIKONOS TTL WIDE ANGLE PHOTOGRAPHY

Wide angle photography using the Nikonos TTL system is a bit more complicated than extension tube work. For Balanced Wide Angle photographs and Close Focus Wide Angle photographs, there are two exposures that must be manipulated: the strobe exposure and the ambient light exposure. You want both of these exposures to be optimum and balanced. Because the portion of the frame that is to be exposed by the strobe may both be small and off center (surrounded by blue water), it is easy for the TTL microcomputer, as smart as it is, to get confused.

Using the TTL for Balanced Wide Angle and Close Focus Wide Angle photography does not produce the consistently perfect results that it does for extension tube photography and therefore requires bracketing. However, once you get the hang of bracketing with the TTL system, you may discover that you can produce more consistent results than bracketing with a manual system.

The problem that the TTL has with these kinds of photographs is that the portion of the frame that is reflecting light back to the lens is often very small. In addition, the reflectivity of this small section is often highly variable. The upper left photo on page 181 shows a diver next to a sponge photographed with the Nikonos V, a Nikonos 15mm lens, and a Nikonos SB-102 TTL strobe. The majority of the frame is open water, which reflects no light back from the strobe. The light meter looks at this portion of the frame and tells the TTL system that more light is needed. The sponge and diver's suit are relatively dark and the diver's face and hands

are highly reflective but comprise a very small portion of the frame. The TTL averages out these factors and the result can be a diver with an over exposed face and hands.

Nikonos TTL Balanced Wide Angle photographs and Close Focus Wide Angle photographs almost always result in over exposures when taken with the ASA/ISO film speed dial set at the ISO number of the film used. The solution to the problem is to manipulate the film speed dial on the camera to compensate for the potential over exposure.

Because the compositions of your frames are variable and the ratios of reflective to non-reflective portions of the photographs change, there is no standard correction that can be recommended to produce perfectly consistent results. Many photographers using the Nikonos TTL system for wide angle photography have found that doubling the ASA/ISO number on the film speed dial produces relatively consistent results for Balanced Wide Angle photographs. But bracketing by changing this setting for each subject is advisable.

BALANCED WIDE ANGLE PHOTOGRAPHY

When taking a Balanced Wide Angle photograph with the Nikonos TTL system, I start by dividing my film's ISO number by two. I then add this number to the film's ISO number and this is my first bracket setting on the film speed dial. I then double the film's ISO number for the second bracket, and then double it again for the third bracket. One of these, usually the middle bracket, is almost always perfect. Sometimes I will take a fourth bracket for which I set the film speed dial to the film's ISO number exactly. But this one almost always comes out a bit hot.

Example: Film ISO number = 100	
Bracket #	Film Speed Dial Setting
#1	150
#2	200
#3	400
#4	100

The Nikonos Manual suggests that the shutter speed be set at A (aperture priority) when using a TTL strobe. At this setting, when the strobe is switched on, the shutter automatically looks at 90th of a second. The ambient exposure will not be made automatically as it is when a strobe is not used. You must select an F number that will produce good background water color. You can do this by looking at the water behind the subject through the view finder and adjusting the lens aperture until the proper exposure is indicated by the LED display. Or you can use an external light meter to select the exposure. That F number will produce a background that should balance with your strobe exposure.

In low light conditions it may be better to choose a slower shutter speed than 90th (produced when the shutter speed is set at A). I usually use 60th of a second for most of my photographs. This allows the use of a 1/2 stop smaller aperture, thus giving me a bit more depth of field than if I use 90th. Sometimes I even use 30th when in dark temperate waters, while deep on wall dives, or during late afternoons. In these situations I rely upon the strobe to freeze motion and the slow shutter speed to give me water color.

CLOSE FOCUS WIDE ANGLE PHOTOGRAPHY

Close Focus Wide Angle Photography with the Nikonos TTL system follows much the same rules as for Balanced Wide Angle photography. Since most of the frame is open water, the TTL will tend to overexpose the relatively small subject.

Bracketing your Close Focus Wide Angle photographs is done exactly the same as with Balanced Wide Angle photographs. However, it is important to remember that when shooting straight up into the sun and using F-22 or F-16, the strobe needs to be extremely close to the subject to produce an exposure. The TTL system will not put more light on the subject than the strobe is capable of at manual full power. And at manual full power and F-22, the strobe to subject distance needs to be about one foot. So if your TTL Close Focus Wide Angle shots are coming out under exposed, it may be your strobe to subject distance that is at fault, not the TTL system.

A major advantage of using the TTL system for Close Focus Wide Angle photographs and Balanced Wide Angle photographs is manifest when working in low light conditions. If the water

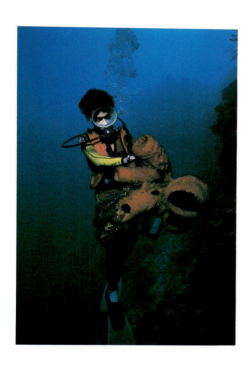

This Balanced Wide Angle photograph was taken with a Nikonos V, a Nikonos 15mm Lens focused at 3½ feet, and a Nikonos SB-102 TTL strobe.

This CFWA photograph was taken with a Nikonos V, Nikonos 15mm lens focued at one foot, and a Nikonos SB-102 TTL strobe.

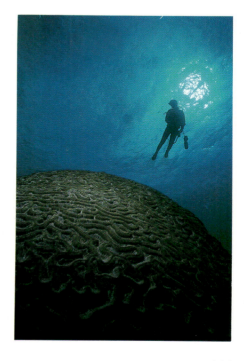

behind the Close Focus Wide Angle subject produces an exposure of F-5, 6 or F-4 (ISO 100 film), it may be almost impossible to hold a manual strobe far enough away, even at low power, to avoid over exposure. Diving in California's dark temperate waters, I have often faced this problem. I have even tied handkerchiefs over my strobe to reduce power. But the TTL system can reduce the power as much as necessary, producing beautifully balanced exposures in very low light conditions.

OTHER TTL SYSTEMS

Many cameras that are used in underwater housings are capable of TTL strobe systems. But the TTL electronics for these cameras operate only with TTL capable strobes that are coded for that type of camera. The Nikonos strobes will not work with Nikon or Canon cameras in housings. Other manufacturers are, however, producing strobe designs that will allow for TTL operation when using a Reflex Macro system or a wide angle lens on an SLR camera within an underwater housing.

TTL exposure systems have obvious advantages for underwater wildlife and action work where things happen quickly and second chances are not always presented. It should be considered strongly by those just gearing up for underwater photography, and even by those of us who think we can live without it.

Equipment Appendix

The following text is a brief

overview of 35mm underwater photographic equipment. Volumes could be written about this subject, but in order to do so with any integrity, one would have to use each piece of available equipment often enough underwater to become familiar with it. Unfortunately, this could take years. In addition, by the time the material was published most of the gear would probably be obsolete.

The equipment available for underwater photography changes rapidly, and every time you open a diving magazine you will notice that there is something new on the market.

The best way to choose your underwater photographic equipment is to first decide what it is that you want your gear to do, then shop for items that meet these criteria. For example, if you intend to take extension tube photographs and you are shopping for a strobe, you should first decide upon the specific features you want the strobe to have. In this case, one that is small, and is compatible with Nikonos brackets and strobe arms would be suitable for extension tube photography. If you want a strobe for use with a Nikonos 15mm lens, then you will want to make sure that it has a suitable beam angle for wide angle coverage and variable power.

Once you know the features you want your equipment to have, then you can go into a dive store or camera shop and ask a salesman to show you what there is currently on the market with those features. First, however, make sure that the salesman is an underwater photographer himself and has used a system similar to what you have in mind. If not, ask for another salesman. If there are no underwater photographers working in the store, then another store might be more helpful.

184

The following sections may provide useful information when you are trying to select your equipment. The equipment shown in the photographs within this appendix are merely examples of specific types of gear. There are also many other items on the market (not pictured here) which are worth considering. A qualified salesman will be able to help you make your choice.

STROBES

Strobes can be divided into two general classifications: big strobes, and little strobes.

WIDE ANGLE STROBES—Big strobes are generally used for wide angle photography. They are quite powerful and produce a wide beam of light. Beam angles for wide angle strobes are at least 85 degrees and some are as wide as 120 degrees. If you are using a 28mm lens, then 85 degrees is more than enough. If, however, you are using a 15mm lens, then 85 degrees will be a little too narrow for complete coverage. However, the 85 degree beam angle of the strobe and the 94 degree beam angle of the 15mm lens are close enough to make the lack of complete coverage almost unnoticeable in most photographs. If, on the other hand, you are using a small strobe with a beam angle of only 60 degrees with the 15mm lens, the lack of coverage will be very obvious.

Another important feature to look for in a wide angle strobe is variable power. A good wide angle strobe should have at least two power settings, and more if possible.

Much of the time you will be using the wide angle strobe as a fill light source. This means that you will be attempting to balance the strobe light with the available light reading. Balancing is much easier if you have some control over strobe power.

All of the wide angle strobes that I am familiar with are more than powerful enough to do good wide angle photography. The fact that one manufacturer's strobe is twice as powerful as another may not be extremely important. In fact, some strobes are too bright for balancing in temperate waters, especially if they

Large, wide angle strobes are a must for obtaining good lighting results when using wide angle lenses underwater. They can also be used effectively with close-up systems.

don't have variable power. Beam angle is a more important consideration than power when choosing a wide angle strobe.

SMALL STROBES—Small strobes are smaller in size, less powerful, and less expensive than large, wide angle strobes. For wide angle photography (28mm lens and wider) they are of little value. However, for macro photography (including extension tube photography) they are superior because they are so much easier to position, carry, and maneuver.

Small strobes usually have a beam angle of 60 degrees or less and are considerably less bright than wide angle strobes. Whereas a small strobe might give you an exposure of f-5.6 at a distance of 3 feet, a wide angle strobe would probably give you a reading close to f-11. However, when the small strobe is used for macro photography, beam angle and brightness are relatively unimportant.

When doing macro photography, a small strobe will give you the same exposure as a large strobe if it is held just a few inches closer. Therefore, when shooting most macro subjects, small strobes are perfectly adequate. In addition, small strobes

186

The above strobes are representative of a wide variety of small strobes available on the market. They are easier to maneuver underwater than large strobes, and are most ideal for macro photography.

are compact enough to allow two strobes to be used at the same time (one slave and one sync). Although it is possible to use two wide angle strobes for macro photography, most photographers find them too cumbersome.

STROBE POWER SUPPLY

There are two ways a strobe can be powered. One is with rechargeable batteries and the other is with disposable batteries.

Rechargeable batteries have two advantages over disposable batteries. One advantage is that they recycle faster. Recycle time is the length of time it takes the capacitors in the strobe to become fully charged. These capacitors must be fully charged before the strobe can fire. The other advantage is more obvious: you don't have to buy batteries for rechargeable strobes. You do, however, have to charge these strobes regularly.

An advantage to using disposable batteries is that you don't have to worry about keeping the batteries charged. When your batteries get low, you just throw them away, replace them with

new ones, and the strobe is ready to use again. When your rechargeable strobe batteries get low, however, you may not be able to use the strobe for several hours assuming, of course, that you can find a 110 V power supply to plug it into.

SLAVE STROBES

Some strobes have a slave setting while others (usually small macro strobes) are designed to operate only on slave.

A slave strobe has a circuit in it that causes it to fire when the slave sensor picks up a sudden increase in ambient light. This circuit allows the slave strobe to fire simultaneously with another strobe.

The slave feature has several advantages. If you are photographing a person who is using a strobe with the slave feature, you can ask them to switch their strobe to "slave". This will cause their strobe to light when you are taking their picture. This "slave" setting is rather common in wide angle strobes and can be used to enhance "people photos" when used in the above fashion.

The slave feature is very important in macro systems where multiple source lighting is so important. Some small strobes are designed without sync cords and can be used only as slaves. Most two-strobe macro systems consist of one sync strobe and one slave strobe.

CONNECTORS

There are several types of strobe-to-camera connectors available. Most new strobes come standard with a Nikonos connector which will plug directly into the Nikonos camera. Most people, however, invest in an underwater connector.

The underwater connector increases the strobe's versatility when a photographer uses more than one camera system. If, for example, you own both a Nikonos and a housed camera system, then it may not be possible to plug a strobe with a Nikonos fitting into the housing. Most serious underwater photographers order

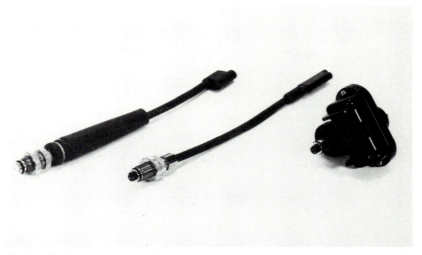

Pictured above are typical strobe-to-camera connectors. For the serious photographer who takes more than one camera system underwater, investing in additional connectors can increase strobe versatility.

their strobe with a male underwater connector. They also get female underwater connectors for their Nikonos and for their housed camera system. This allows their strobe to be plugged into either system while underwater.

There are several underwater connector systems available and all seem to have about equal reliability.

CAMERA HOUSINGS

Underwater housings are commercially available for a wide variety of above water cameras. Generally these housings are made out of either anodized aluminum or some type of plastic (usually lexan, plexiglass or PVC). All of these materials can be used to make equally excellent housings, but it is the actual design of the housing itself which is most important.

There are several important things to look for in a housing design. You want to make sure that the design is simple, allowing the camera to mount in the housing in a relatively foolproof manner, requiring minimal adjustment. Make sure that the controls are easy to reach and can be manipulated easily underwater. It is

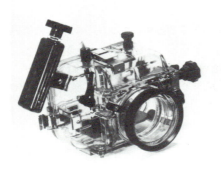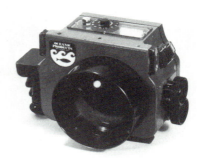

Underwater housings are available in a wide range of sizes, shapes and materials, from standard commercial types to custom-designed and homemade models.

also important that your housing has facilities for easy mounting of strobe arms and light meters. And, most importantly, you will want to be certain that the housing is available with necessary ports for the lenses you intend to use (a dome port for the specific wide angle lenses you have in mind, and a flat port for macro).

It is always a good idea to talk with someone who uses or is familiar with a housing for the kind of camera you plan to use. If you haven't purchased your above water camera, it is best to shop for one with those features that allow it to work especially well in an underwater housing. One of these features is an optional actionfinder or sportsfinder.

The sportsfinder is a large prism that attaches to the top of the camera after the standard viewfinder has been removed. This sportsfinder produces a very large image which can be viewed from several inches away, making it ideal for an underwater housing. Most above water cameras don't have facilities for removing the standard viewfinder and mounting a sportsfinder. Some models of Nikon and Canon cameras do offer this option, however.

If you have a camera that is not designed to accept a sports-finder, you are not necessarily out of luck. Several housing manufacturers, and some above water camera manufacturers, make a supplementary lens that attaches to the standard viewfinder, creating a larger image. These magnifying lenses are not as easy to use underwater as sportsfinders, but they are acceptable.

If you plan to house a camera which won't accept either a supplementary magnifying lens or sportsfinder, you will be making a mistake. The main advantage to using a single lens reflex camera in an underwater housing is that it enables you to see through the lens well enough to compose your photographs. If you are not going to be able to see through your viewfinder, you are wasting your time with this system.

LENSES FOR USE WITH HOUSED CAMERAS

The number of above water lenses that could be used in underwater housings is enormous. However, the number of lenses that are most commonly used are relatively few.

For macro photography, most photographers use 50mm to 55mm macro lenses (not to be confused with 50mm non-macro lenses). However, some photographers occasionally use macro lenses as long as 105mm.

A greater variety of wide angle lenses are commonly used underwater. Underwater photographers use wide angle lenses from 35mm to 16mm fisheyes. However, the most common lenses used are 24mm, 20mm, and 16mm. A 20mm lens has a picture angle of about 95 degrees (similar to the Nikonos 15mm lens). Any of these three lenses can be used to do excellent wide angle photography or close focus wide angle photography (CFWA).

If you are using a wide angle lens behind a dome port you may find that the lens doesn't focus close enough to do CFWA work due to the closeness of the virtual image produced by the dome. You can solve this problem by adding a +2 or +3 diopter lens to the front of your wide angle lens (see Chapter 2 "Refraction").

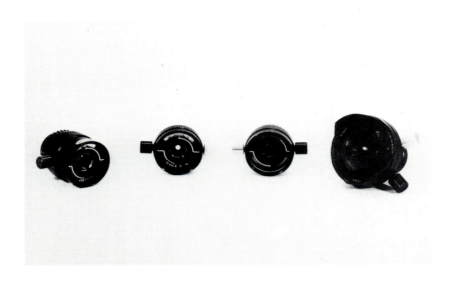

LENSES FOR THE NIKONOS CAMERA

Nikon makes four lenses for the Nikonos camera: the 80mm, 35mm, 28mm, and the 15mm. The 80mm has no real underwater application and was meant to be used with the Nikonos above water. The 35mm lens is designed to function both above and underwater. The remaining two lenses are designed to be used only underwater. Chapter 11 gives an overview of the capability of both the 28mm and 35mm lenses. Chapters 4, 5, 9, and 10 contain numerous examples of the capabilities of the Nikonos 15mm lens. In addition, Chapter 2 gives a comparison of the angles of these lenses.

There are some lenses available for the Nikonos camera that are made by other manufacturers. Among these are the Sea and Sea 20mm lens, and the Subsea 20mm lens, and the Seacor 21mm lens. These wide angle lenses have lens angles and functions similar to the Nikonos 15mm.

There are some supplementary lenses designed to increase the angle of the Nikonos 35mm lens. These lenses simply attach to the front of the 35mm. Some of these supplementary lenses will

increase the Nikonos 35mm lens' angle to simulate a 28mm, a 20mm, or even a fisheye lens. In addition, these lenses are available at a fraction of the cost of the lens they are intended to simulate.

Of course, there must be some disadvantage to these supplementary wide angle lenses or no one would spend the money for a 15mm, 20mm, or 21mm prime lens. The fact is, supplementary lenses do not produce the image quality that prime lenses do. However, depending on what you want to accomplish with your photography and how you wish to use your photographs, you may find this reduction in quality acceptable.

LENS SYSTEMS FOR NIKONOS MACRO PHOTOGRAPHY

There are two ways that you can take macro photographs with your Nikonos camera. One is with extension tubes and the other is with supplementary close-up lenses.

An overview with examples of extension tube photography is available in Chapter 6.

Several manufacturers make supplementary close-up lenses for use with the Nikonos 35mm lens. One such system is made by Nikon.

The best way to take macro photographs with a Nikonos is with extension tubes, since no supplementary optics are necessary. However, many of the available supplementary close-up lenses do produce excellent images. Supplementary lenses also have the added advantage of being removable underwater, thus allowing the 35mm lens to be used by itself should the opportunity present itself.

Index

Actual distance 22
Ambient light 63,66,86,88,103,
 116,118
Anemone 92
Animals 100-103,166
 photographing 100-103
 behavior 166
Aperture setting 12,15,16,18,41,
 63,64,66,83,85,88,130,133
 and depth of field 18
 available light 41
 close focus wide angle
 130,133
 definition of 15,16
 extension tubes 63,64,66
 reflex macro 83,85,88
Apparent distance 22
Artificial light - *See Strobe light*
ASA rating 12,13,16
Automatic exposure 173-182
Available light 26,29,66,86,87,116
 balancing 86,87
 color distortion 26
 exposure 29
Available light photography
 7,17,27,37-50
 color absorption 40
 contrast 38,39
 light source 17
 limitations of 38
 macro subjects 41,42
 negative space 41-43
 procedures for 42,43
 scatter 38,40
 separation 39,40
 sun position 40,41

Backscatter 30,31-33,64,65,70
 with two strobes 70,33
 extension tubes 64,65
 diving techniques 30,31
 strobe placement 31-33
Balancing exposures 29,86-88,
 103,115,116,118,130
Batfish 109,110
Batteries 177,178
Beam angle 84,118,132,174-176
Behavioral photographs 166
Bracketing exposures 64,65,68,83

Canon 180
Camera angle 44,49,73,92,101,
 102,106,109,110,122,134,136
Camera motion 14
Camera systems 9,173-183
CC30R filter 29,117
Chrinoid 134
Close focus wide angle
 photography 8,129-139
 balancing exposures 130
 equipment needed 131
 negative space 132
 perspective 131
 procedures for 132,133
Colors 13,14,24-30,114-118,
 143, 150
 blues 13,14,24-27
 filters 26,27
 light 24-26
 Nikonos 35mm lens 143,150

photographing people
114-118
reds 24-27
strobes 28-30
Color absorption 24,25,26,29,38,
40,116,142,143,146
available light 38,40
Nikonos 35mm lens 142,143
strobe light 29
Color correction filter 26,29
Color distortion 26
Color imbalance 26
Color spectrum 24
Composition 42,43,65,67,114,115
Connectors 178,179
Contrast 38-41,66
color 37,38,66
shade 38-40
Coral Sea 48,72,73,124,12,134

Depth of field 18,19,41,63,101,
130,131,133
and framers 63
and lens angle 19
definition of 18
Diopter 3,131,139,181
Diver photographs - *See People
photographs*
Dolphins 15,46,47
Dome port 35,36,82,87,118,131,
180

Ektachrome film 13,14,117,120,
147
Equipment, photographic 7-10,
173-183
limitations of 8-10
appendix 173-183
Exposure 12-16,27,29,52-54,
63-66,68,71,83-88,133,134
and filters 27
bracketing 64,65,68,83
extension tubes 63-66,71

reflex macro 85-88
silhouettes 52-54
Extension tubes 61-79,83,85,102,
183
definition of 62,63
Extension tube photography
61-79, 83,85,130,174
and aperture 63,64
backscatter 4,65
composition 65,67
depth of field 63
equipment needed 62,63,174
framers 63,64
framing 65,57
negative space 65-67
procedures for 71
Eyes, photographing 101,115

Face distortion 34
Fill light 29,103,175
Fill Lighting - *See Balancing*
Film formats 13,14,26
Film speed 12,13,15
Filters 26,27,29
Filter factor 27
Fisheye lens 120-122
Flash bulbs 28
Flat ports 34-36,82,87
and refraction 35,36
and macro photography
35,36
F-number - *See F-stop*
Focal length 15,16,20,64
Focusing 12,18,19,22,34,41,63,
71,101,103,131-133,144
and depth of field 18,19
and refraction 34,144
Framer 63,64,85,72
Framing subjects 64,67,71,88,90,
144
F-stop 9,12,15-18,62
Fundamental photographic
principals 9-22

Garibaldi 78,79,122,136,137
Gorgonian coral 92,12,139
Guide numbers 16-18,64,85,86,88
 and reflex macro 85,86,88
 and strobes 16-18
 extension tube exposure 64

Horizontal color loss 27,28,34
 illustration 28
Horizontal photographs 43,46,88
Housed cameras 118,178,179
Housings, underwater 34,35,
 82-84, 131,179,180

Identification photographs 100

Kelp 44,77,110,120,121
Kodachrome film 13,14,117
Kodak 13

Lens, macro - *See Macro lens*
Lens, wide angle - *See Wide*
 angle lens
Lens angle 12,19-21,24
 comparisons 20,21
Lens systems 181-183
Light meter 13,16,84,86,88,
 103,115,118,180
 and available light 42,43
 and silhouettes 53-54
Light, underwater 8,13-15,17,
 24-33,45,46,68-70
 aperture 15
 backscatter 30,31
 balancing exposures 86
 color absorption 24-26,29
 film speed 13,14
 filters 26,27

 limitations of 24
 scatter 33
 shadows 32,68-70
 strobes 17,28,68,8
Lobster 120,121

Macro lens 82,83,181
Macro photography 7,19,28,32,
 35,36,41,42,62,66,67,130,176
 - *See also Reflex macro and*
 Extension tube photography
 and available light 41,42
 and colors 28
 dome ports 35
 flat ports 35,36
 negative space 42
 strobes 32
Magazines 6,7,10,100,159,161,162
Manta ray 149,158,16,168,169
Marine wildlife portraits 99-111,
 164
 camera angle 101-102
 depth of field 101
 lighting 102
 philosophy of 100,101
 procedures for 103
Model, underwater 115,117-119,
 132
Monochromatic 38-40
Moray eel 152,153,160
Movie lights 28

Negative space 41-43,65-67,77,
 78,88,92,96,110,14-116,124,
 126,130-134,139,152
 and diver photos 119
 definition of 41
 in extension tube photos
 65-67
Nikon 20,21,83,85,180,183
 camera 83,85
 16mm lens 20,21

disadvantages of 82,83
equipment needed 82,83
guide numbers for 85-87
procedures for 89
strobe positioning 87,88
Refraction 22,34-36,87,115,131,
144
and face distortion 34
and flat ports 35,36
and focusing 22,34
Rockfish 90,91
Round file 13,65,101,159

Scatter 32,33,28,40,44,45,56,87,
142,143
Sea lions 15
Sea of Cortez 59,92,152
Sea snake 72,73,126,127
Sea urchins 94,95,144
Seacor 21mm lens 131
Selling underwater photos
155-171
publishers 159
photo stories 160-163
writing 160,161
Separation 38-40,48,49,52,56,59,
66,119,126
Shade contrast - *See Separation*
Shadows 32,33,69,70,88,102,109
and strobe placement 32,33,
88
Shark, photographing 48-50,54,
55,59,60,104,105,145-147,163,
170,171
Shutter speed 12-16,52,54,63
and extension tubes 63
and lighting 16
silhouette photos 52,54
Silhouette photographs 7,39,46,
51-60,66,130,140
equipment needed 52
exposures for 52-54
light meters 52-54
procedures for 54

close-up system 183
Nikonos brackets 70
Nikonos camera 9,22,34,48,62-68,
70,83,85,88,117,118,133,146,
168,182,183
and extension tube photos
62-68
and lenses 182,183
and extension tubes 62-68
Nikonos lenses 8,9,18-21,42,48,
49,59,62,118,130,131,141-153,
182,183
15mm lens 21,130,131,143,
144
28mm lens 19-21,42,62,118,
131,145
35mm lens 8,9,18-20,42,62,
131,141-153
80mm lens 182
Nudibranch 41,42,96,97,144

Parallax 144,150
Perspective 131,136
People photographs 113-127
and composition 114,115
equipment needed 115,118
procedures for 118,119
Photograph evaluation 7-10,12,
19,28
Photo library 159,161
Photo story 160-163
Primary light source 15,17,29,32,
63,66
and extension tubes 3,66
and macro photos 29
Portrait - *See Marine wildlife
portraits*
Publishers 7,13,67,143,158-161
and selling photos 158-161

Reflex macro photography 20,
80-97,102

sun position 52-54
shutter speed 52
Silicone mask 117
Single lens reflex camera 22,44,
82,83,181
Skin tones 27,114,116,117,122
Slave strobe 84,85,94,122,124,
178
Slide show 156
Small strobes 9,70,71,73,77,84,
118,131,174,176
Specialization 62,74
Spiral gill worm 74,75
Sportsfinder 83,180,181
Squid 159,162,163
Starfish 158,159,166,167
Stopping action 14,15,52
Strobes 15-18,26-33,62-64,66-71,
84-88,102,130,175-179
 backscatter 30
 balancing 29
 color absorption 29
 exposures 29
 guide numbers for 16-18
 housing ports 87
 lighting techniques 31
Strobe flash 15
Strobe power 122,175,177,178
Sun, lighting effects 40,41,43,45,
46,48,52-54,68,69,74,77,130-133
Supplementary lens 181-183

Telephoto lens 33,124

Topside photography 24,40
Tube - *See Extension tube*

Underwater photographer 10,12,
13,157
Underwater photographs 6-9,12,
24,155-171
 how to sell 155-171

Vertical color absorption 25,27
Vertical photographs 43,46,88,
133
Viewfinder 88,14,150,180,181
Virtual image 36,181

Whale 156,5,57,156,164,165
Wide angle lens 20,21,24,28,29,
33-35,41,42,44,52,54,84,100,
103,115-118,130,131,143,144,
181,182
 and available light 41,42
 and silhouettes 52,54
 dome ports 35
 techniques 24
Wide angle strobe 8,17,71,84,
115,118,131,132,175,176
Wildlife photography 7,24
Wildlife portraits 99-111